Photographic Retouching
and
Air-Brush Techniques

Photographic Retouching
and
Air-Brush Techniques

JOHN R. PODRACKY
Professional Photographer

Prentice-Hall, Inc., Englewood Cliffs, NJ 07632

Library of Congress Cataloging in Publication Data

Podracky, John.
Photographic retouching and airbrush techniques.

Includes index.
1. Photography—Retouching. 2. Airbrush art. I. Title.
TR310.P62 770'.284 79-18905
ISBN 0-13-665257-3

Interior design and editorial/production supervision by Steven Bobker
Cover design by Infield/D'astolfo Associates
Cover photo by the author
Manufacturing buyer: Gordon Osbourne

10 9 8 7 6 5 4 3 2 1

Printed in the United States of America

Prentice-Hall International, Inc., *London*
Prentice-Hall of Australia Pty. Limited, *Sydney*
Prentice-Hall of Canada, Ltd., *Toronto*
Prentice-Hall of India Private Limited, *New Delhi*
Prentice-Hall of Japan, Inc., *Tokyo*
Prentice-Hall of Southeast Asia Pte. Ltd., *Singapore*
Whitehall Books Limited, *Wellington, New Zealand*

Contents

Preface

The term *photographic retouching* is an elastic or general phrase used to cover a number of distinct technical processes used in both industry and artistic areas. A common denominator of all the areas is the need to alter or improve a photographic image, either before or after the printing of the negative. The result is a more precise achievement of the visual goals originally intended for a particular image.

There are a variety of approaches to these processes and it is my intent to describe them in sufficient detail, pro and con, to allow an artist faced with a specific problem to choose the working method, from a standing body of knowledge or vocabulary of techniques, which will offer the greatest chance of success.

In the retouching of photographic prints, one of the most useful and effective tools available to the artist is the air-brush. The air-brush (in one form or another) has been in existence for a considerable length of time. The modern air-brush is a highly specialized instrument available in many different designs for a wide spectrum of purposes. In recent years the air-brush has exceeded the bounds of traditional commercial art uses and has found a growing acceptance in fine art areas (i.e., in creating photorealist and abstract paintings as well as in some print-making techniques.)

The successful retouching artist is a person possessing both hand skills and visual judgement and discrimination. These abilities are not necessarily talent, but learned skills based on information gleaned from experience and a background of extensive process information.

Some portions of the print retouching process simply cannot be learned from written instructions or information, no matter how complete or precise, but must be experienced and experimented with over a period of time in order to achieve dexterity and self-assurance in the face of different situations and problems. One such area (to be covered in detail) is emulsion tone matching in color and black and white.

Photographic retouching is not a difficult group of processes to learn, but doing so does require the assumption of an attitude of enthusiasm, the determination to adhere to self-imposed disciplines, and step by step care to achieve consistent results of a satisfactory and professional nature.

No doubt, once under way, and as experience accumulates you will devise variations on the approaches covered in this book, to suit your own specialized needs and best achieve your desired results. This is as it should be for retouching is as much a creative process as it is a technical one. Good luck.

John R. Padracky

Photographic Retouching
and
Air-Brush Techniques

1
Preparation for Retouching

CHAPTER 1

MOUNTING THE PRINT

Before a decision can be reached as to how to best correct or alter a photographic print, the first consideration must be the proper mounting of the print to create the best possible surface to receive the retouching materials.

In industrial situations (such as photographs from stock files or picture agencies) photographic prints are usually supplied on single-weight glossy or semi-gloss surfaces. Even if double-weight photo stock is used, or available, a rigid backing, somewhat larger than the print itself is an absolute necessity. This is true no matter how extensive or minimal the actual amount of retouching is to be, or whether that corrective work is to be done on the actual print surface, or on an acetate overlay.

Photographic papers are subject to environmental conditions that can alter their dimensional stability (i.e. high humidity, or dry air in the work area, or even the warmth of your hands) and can buckle, blister, stretch, or curl if left unmounted, or improperly mounted. In addition, if in the actual retouching

3

you should wish to work directly on the print surface, the localized wetness from paint, or dye will cause an area on the print surface which can stretch or "lift", and upon drying crack, craze or fracture.

There are at present two reliable methods of mounting photographic prints for retouching purposes. These are rubber cement mounting and dry (heat press) mounting.

RUBBER CEMENT MOUNTING

Rubber cement is a liquid adhesive with a viscous or syrup-like texture. The vehicle of this cement is a highly volatile (and flammable) petroleum distillate which evaporates very quickly. After it is applied to a surface it will dry from a wet, glossy state to a matte dull gummy texture. If during application the texture should appear lumpy, or very ropey, and the cement clings to the applicator jar or brush more than to the surface you wish to apply it to, add and mix thoroughly a small amount of rubber cement thinner (which is actually the vehicle of the original cement) until it brushes on easily, evenly, and quickly.

The strongest bond obtainable with this adhesive is produced when *both* surfaces to be bonded are equally coated, and allowed to dry before being placed in contact.

When mounting a photographic print by this method, begin by selecting a rigid support (mat board, cardboard, or

Figure 1-1. When applying rubber cement to the mounting surface, cover an area larger than the print to be mounted.

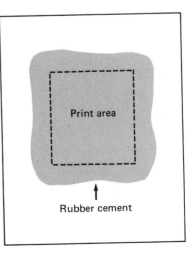

Print area

Rubber cement

foam-core board) somewhat larger than the dimensions of the print. Coat the *board surface* with an even coat of rubber cement, also larger than the size of the print, and allow to dry as shown in Fig. 1–1. Then apply an even coat to the *back of the print,* and allow it to dry.

For prints up to and including 8″ × 10″, use the following application method: line up the top edge of the print so that it is parallel with the top edge of the mounting board. Gently press the top edge of the print until it adheres evenly along that line. Then, holding the print with a slight curl, press from the center of the print towards the edges while "feeding" the print slowly down. Make sure there are no trapped air bubbles, or creases beginning. This technique is illustrated in Fig. 1–2.

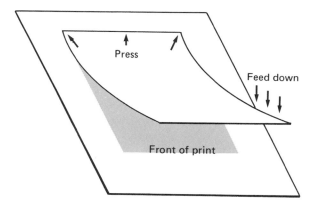

Figure 1–2. Having coated the back of the print and the mounting surface with rubber cement, tack one edge of the print down, keeping the print bent at a slight curve. Gently feed it down, pressing as it comes into contact with the surface.

After you have tacked down the print to your satisfaction, press it down more firmly with the aid of a soft cloth or tissue paper (to prevent marring or getting fingerprint smudges on the surface).

If, during the process of tacking the print down, an air pocket or bubble produces a "lift" in the surface, don't continue. If you cannot gently squeeze it out, don't force the area down as this can cause a crease, or even crack the surface emulsion of the print. In the event of a problem as this, it is best to remove the print, and try a different method of mounting. To remove the partly tacked down print, hold the untacked portion up, and apply a small amount of rubber cement thinner along the contact seam, using your dispenser. Allow the thinner to soak in a few seconds and gently pull the print up until

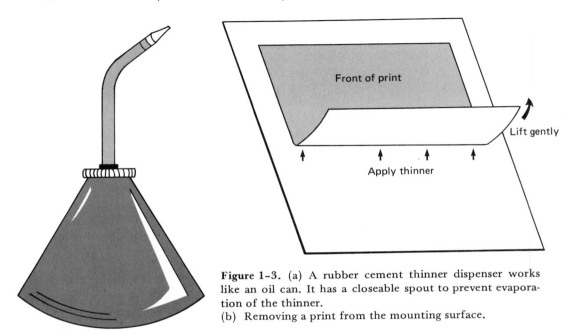

Figure 1–3. (a) A rubber cement thinner dispenser works like an oil can. It has a closeable spout to prevent evaporation of the thinner.
(b) Removing a print from the mounting surface.

resistance is met. Repeat this procedure on each newly exposed area until the print comes free. Removing a print is shown in Fig. 1–3.

Once you have the print and the backing apart, allow it to dry thoroughly. Then recoat both the board (if it has not warped) and the back of the print with rubber cement and try again, or try the procedure for larger prints described below.

Photographic prints larger than 8″ × 10″ are frequently quite hard to mount by the previous method. If a print is large, especially if the print paper is single weight, it will be very prone to air bubbles, stretching, or creasing during the rubber cement mounting process. Additionally, the larger size makes the initial tacking procedure quite cumbersome. The best method of minimizing these dangers is to employ the *slip-sheet* method of mounting. This procedure employs two sheets of tracing paper pulled in opposite directions while tacking the print down. In this way a small area of contact is gradually increased, from the center out towards the far edges of the print. Slip sheeting is shown in Fig. 1–4.

The first step of the slip-sheet method is identical to that of the first method. Coat both the mounting board and print back with rubber cement. After both areas have fully dried, place two sheets of tracing paper larger than both the print and the coated area on the mount board gently in place between the board and the print. Position the print to your satisfaction (taking care to insure it is within the rubber cement area on the mounting board) then pull the upper and lower slip sheets a small amount to *open up* about a one-inch column across the print. Gently press across this area from the center out with a soft cloth or tissue. Pull the slip sheets again and increase the width of the tacked area in approximate one-inch increments until the entire print is tacked down. At this point you may press the print area with a soft cloth for the final time.

If, for any reason you have to remove the print during the tacking procedure, simply leave one slip sheet down, remove the other, and follow the removal procedure described earlier.

After the print has been mounted, remove the excess rubber cement on the mounting board by gently rubbing a rubber cement pick-up on the visible cement.

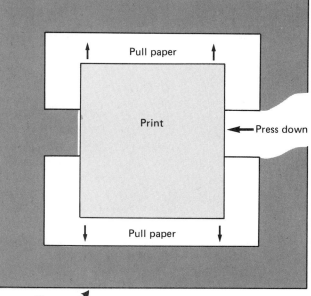

Figure 1–4. (a) A rubber cement dispenser jar with adjustable height brush.
(b) The slip-sheet method of rubber cement mounting.

DRY MOUNTING

The only other reliable procedure for mounting a photographic print is to employ a dry mounting press and materials. The heart of this method is a thin sheet of heat activated wax adhesive, called dry mounting tissue. This tissue takes the place of rubber cement in bonding the print to the board or support. It is heated by a dry mounting press to a sufficient temperature to cause it to melt and adhere the two surfaces together. When properly done, the dry mounting procedure produces a very high quality, smooth, bubble free bond. The bond can be permanent or (depending on the tissue used) removable by reheating. You should follow the manufacturers' recommendations

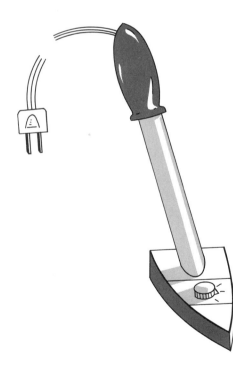

Figure 1-5. (a) An electrically heated tacking iron for dry mounting.

(b) The electrically heated dry mounting press. (It is shown with a print and mount partially inserted.)

with regards to the temperature settings on the press for the type of tissue you wish to use. A device called a "tacking iron" is also necessary to this system. The iron is an electrically heated platen on an insulated handle. This platen (frequently coated with a nonstick surface) is used in tacking the dry mount tissue into proper position on the back of the print, and later to position the print on the board prior to insertion in the press. See Fig. 1–5. The length of time required for the print to be in the press for proper bonding should be determined by reference to the manufacturer's instructions and experimentation. The dry mounting method of print mounting is a fast and excellent one if materials are available to you.

SUGGESTIONS FOR BETTER PRINT MOUNTING

Regardless of the method you choose, you will find it helpful to have either a paper cutter (board type), a sharp X-acto knife, or a single-edge razor blade handy to trim prints and boards. A metal edge T square aids in cutting and is also used to square up prints parallel to the mount edge prior to tacking down.

Recently, new products have been made available for print mounting which combine elements of both of the methods described earlier. These materials are self-adhesive sheets which one merely presses down after having removed a protective sheet on each side. While faster than dry-mounting, and less complicated than rubber cement mounting, I have found that the bond produced by these sheets is not as sound, permanent, or reliable as is necessary in the retouching process. This may change in time, however, because products are always being improved and it pays to keep abreast of new developments in the industry.

A SPECIAL NOTE ON RESIN-COATED PAPERS

In recent years the photographic industry has introduced a type of print paper which has found favor with individual professionals and commercial users on a fairly large scale. This rapid dry, resin-coated material (available in both polycontrast and regular numbered grades) is very easy and fast to process, as well as dimensionally stable (since it is far more water resistant than conventional print papers.) However, because these

materials are not truly paper, they have different characteristics with regards to both mounting and retouching.

Resin-coated prints (either gloss or matte surfaces) resemble conventional prints insofar as image, tone, and clarity are concerned. The weight of the RC material is slightly heavier than single weight regular stock. The back of these enlargements, however, has a semi-gloss texture, and a plastic "feel", unlike paper photographic products. You cannot dry-mount RC prints the same way as other papers. There are considerable differences in the temperature of the press (much less heat for RC) and special dry mount tissue is required. If mounted with too much heat, RC materials will burn, or melt. Manufacturer's instructions for both the press and the special dry-mount tissue should be closely followed if you wish to heat press mount RC products.

PREPARING THE PRINT FOR RETOUCHING

Since photographic retouching is a corrective process, before the actual work on a print begins the artist must make some decisions with regards to how much and/or many corrections must be made. Additionally, whether the print must be preserved in its original state, or can be altered on its actual emulsion surface must be known and considered. In commercial applications, these preliminary details are frequently taken care of in the form of specific directions to the retouching artist by the art director, layout artist, or some other source. If not, the retoucher should take care to discover all necessary information before any work begins.

When extensive retouching is required on a given print this almost always means that the print will have to be rephotographed afterwards. Air brush, or extensive manual retouching leaves delicate, matte areas on the print surface which will flake, crack, or fall off if too much handling takes place. However, even extensive retouching and rephotographing the corrected print is better than having the original object or scene rephotographed. This is because of the time and expense involved and the frequently spontaneous nature of photographs (i.e., press photos, street scenes, fires, etc.) Industries and agencies will generally exhaust all efforts with regards to retouching the print to make it acceptable first, before considering reshooting the original subject.

On occasion, the retouching artist will receive a print for correction which must be preserved in its original state. Prints on loan from agencies, photographic libraries, or stock files sometimes require specialized retouching for one-time use (such as areas for super-imposed type) and afterwards will be needed in their original state again for other uses. In such cases, after

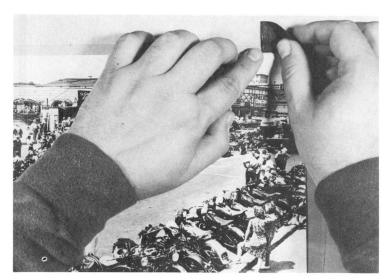

Figure 1-6. (a) Taping down an acetate overlay.

(b) Depending on the size of the print pieces of tape at the top and bottom, as well as the sides can be used. The acetate would lie flat against the print surface.

Figure 1-7. (a) Applying strips of black or white photo tape to protect the image edge, and the mount surface from being soiled during retouching.

(b) After the retouching process, if the photo tape borders are soiled, they can be removed and or replaced.

mounting the print, all retouching work of a major nature should be done on an overlay sheet of prepared acetate. After rephotographing the corrected print, the acetate can be removed, and discarded, leaving the original image intact, and unaltered. See Fig. 1-6.

The overlay is a sheet of *prepared* acetate (acetate which

has been treated to accept retouching colors.) The sheet should be larger than the photograph it covers, and can, if you wish, cover the entire mounting board (to remove the risk of over-spray staining the mount). It is affixed to the mount by removable photo tape. The photo tape can also be used as a protective mat to mark the edges of the print image beneath the acetate. See Fig. 1–7.

When preserving the original print is not of primary concern, and the total amount of retouching does not involve major and extensive surface areas, the acetate overlay may be dispensed with. Bear in mind however that extra care should be taken in both color mixing, and neatness when working directly on the print surface as removing retouching colors is a delicate and difficult procedure. (See Chapter 3 on mixing colors for black and white prints.)

The emulsion, or image carrying part of the print surface, is a fairly delicate and easy to injure area. Prints which have a ferrotype (very glossy) or semi-gloss surface are partly sealed against moisture or water. Thus, it is necessary to prepare the print surface to receive retouching colors, which have a water base. This is not necessary when using penetrating dyes for spotting.

Print surface preparation can be achieved in a number of ways. One method is to use a *dry scrub* with a mildly abrasive powder to provide an almost microscopic *tooth* which will allow proper and even color application. A very fine pumice powder (sometimes called *pounce*) is available from some graphic and art supply firms. It is specifically designed for retouching use. A commercial cleanser with a flour-like texture (such as Bon Ami or similar) can also be used.

Make absolutely sure that the print surface is free of any kind of water, or moisture from your hands. Apply a small amount of pumice, or cleanser to the surface (a few pinches, or use a shaker-type applicator) and *very gently* rub it across the surface in circular motions with a soft cloth or facial tissue. Keep in mind that too much pressure, or scrubbing too long can scratch or scar the emulsion and produce a pattern of streaks, or cause a grey film effect on dark areas in the image which will show up when the print is rephotographed. After the scrubbing process, whisk away all of the powder with another clean tissue and touch the print surface as little as possible with bare hands (finger and/or palm prints will interfere with retouch color application). If you find it necessary to rest your hands on the

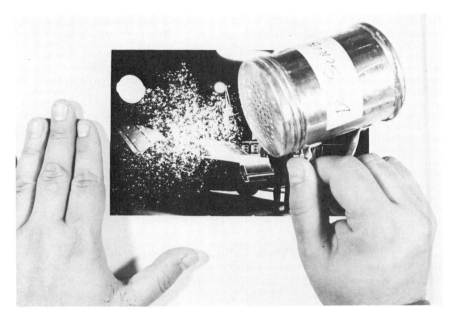

Figure 1-8. (a) Applying scrubbing powder to the print surface with a shaker container.

(b) Gently rub the dry powder across the print surface.

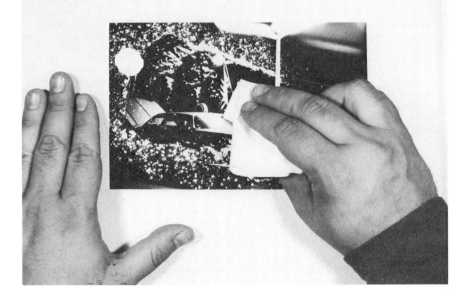

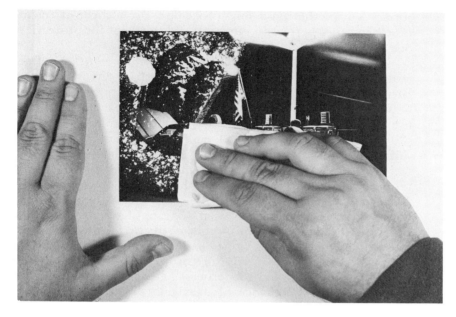

(c) Whisking the powder off with a clean cloth or tissue.

(d) Protect the freshly cleaned print surface from finger and hand prints by resting your hands on a sheet of scrap paper.

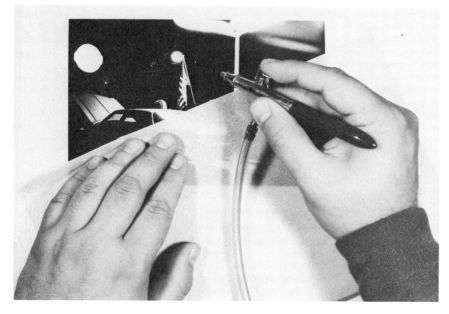

surface during the retouching procedure, use a sheet of tracing or other paper between your hand and the print for protection. See Fig. 1–8.

There is a commercially prepared *print conditioner* fluid available which acts as a cleanser for surface dirt, grease, and chemicals. In addition, this product produces a receptive film or surface which will accept retouching paints. If you decide to use this method rather than dry-scrubbing, follow the print protection methods described earlier, so as not to resoil the surface.

An important point to remember, should you decide to retouch the actual print surface rather than on an acetate overlay, is to be very sure of both the exact area you are working on, and that you have the exact tone or shade of retouching color you need to accomplish your corrective work. Removing retouching paints (as mentioned earlier) involves gently washing the print surface with the use of cotton swabs, or cotton balls soaked in water. Should this process become necessary it obviously increases the chance of damaging the thin emulsion, is time consuming, and thus potentially costly. A good habit to cultivate in the retouching area is always to think through the various steps needed to completion of a project, thoroughly from beginning to end, before you ever pick up a brush, or mix a drop of paint.

GLOSSARY

ACETATE SHEETS Acetate is a thin, clear, somewhat brittle plastic, available in sheets in a variety of sizes. It is usually produced in a *plain* and a *prepared* form. The prepared form is manufactured with one or both sides capable of accepting wet mediums such as India ink or retouching paint. Acetate is used as a second surface to do corrective work on when the original print surface must be left untouched. It also has uses in the production of masks and stencils, another major part of the retouching process.

DRY MOUNTING A process by which a photographic print is affixed to a mounting surface. This procedure utilizes a sheet of wax-like adhesive

which is positioned between the back of the print and the mounting board. This combination is then subjected to heat and even pressure by placing it in an electrically-heated dry-mounting press which causes an adhesive bond to form by melting the wax-like sheet. This process can produce both permanent and removable bonds, depending on the type of adhesive used.

DRY-MOUNTING TISSUE A wax-like adhesive sheet (available in different sizes) used as the bonding medium in the dry-mounting process. Depending on the type of tissue used, a permanent or removable bond can be achieved.

DRY-SCRUB The action of gently rubbing an abrasive powder over the emulsion of a print to prepare it for direct surface retouching. A fine flour-like texture pumice powder can be used for this process, or a commercial cleaning powder such as "Bon Ami" or similar fine powder may be used.

EMULSION The coating on the front surface of a sheet of photographic paper which carries the actual image. This term is also used to describe any surface which is chemically coated and sensitized to light (as in film emulsion).

MOUNT A rigid support surface, usually cardboard, matboard, foam-core board, or heavy paper, to which a photographic print is affixed to hold it flat and keep it from curling and buckling during the retouching process.

MOUNTING The procedure and process by which a photographic print is affixed to the mounting board. This is usually achieved with the use of rubber cement or a dry-mounting press.

PHOTOTAPE Quite similar to ordinary masking tape. It is usually available in white or black, and in a variety of widths. (The one inch wide roll is a good general-use size.) Phototape has many uses in the retouching process. It holds acetate in place, acts as a mask or shield for areas, and is useful in the silhouetting process.

REPHOTOGRAPH The process by which a corrected or retouched print is copied to produce a final, finished version of the image. This is done by a photographer or a lab technician, usually with the aid of a special "copy" camera.

RESIN-COATED PHOTOGRAPHIC PAPER A relatively recent innovation in the photographic industry. This material is coated with a resin which makes the paper more resistant to water and dimensionally more stable than conventional enlargement papers. Because of its moisture repellent qualities, emulsion surface retouching is frequently difficult, and an acetate overlay may be necessary.

RUBBER CEMENT A liquid adhesive with a viscous or syrup-like texture. The liquid base of rubber cement is a highly volatile and flammable

petroleum distillate. Rubber cement is not considered a permanent adhesive. It is used to mount photographs for retouching and has many other uses in the graphic arts area.

RUBBER CEMENT PICK-UP A small, eraser shaped piece of rubber with a sponge-like texture that is used to remove excess dried rubber cement from various surfaces (by rubbing gently over these areas).

SHADES A series of gradations running from the darkest black to the white of the photographic paper. The shade (also known as tonal scale) refers to the number of separate gradations between black and white. This number varies with the type of contrast grade the individual paper has. A high contrast grade print paper, for example, #4 has *fewer* shades between black and white than such softer contrast grade papers as #1, or 2, or 3. Retouching paints are usually manufactured in gradations numbered from 1 (the lightest gray) to 6 (the darkest) plus black and white. Shades between these numbers can be mixed to produce a very wide range of grays.

SUPERIMPOSED A term in retouching, used to describe a situation where one type of graphic material is placed over another. One example of this would be a sheet of clear acetate placed over a print as a secondary retouching surface. In this case the retouching for the print would be superimposed over the original image. Often, type is superimposed over a photograph as part of a graphic design layout.

SWAB A short cardboard, plastic, or wooden stick with a small ball of white cotton on one or both ends. Cotton swabs are quite useful in removing paint from a print or acetate surface and for other related clean-up jobs. Several commercial brands of medical swabs are readily available.

TACKING IRON A handle with an electrically-heated platen at one end (sometimes "nonstick" coated) which is used to adhere dry-mounting adhesive sheets to the back of a print, and to the mounting board as a method of positioning them to avoid slipping or shifting before placing them in the dry-mounting press.

TONE Photographic tones are the basic colors of the emulsion image. Most modern photographic prints have a blue–black, cold tone, however some papers produce a brown-black, warm tone. In addition, prints can also be toned different colors by a chemical bath. Colors such as blue, red, brown, sepia, green, etc., are possible.

TRACING PAPER A thin, semi-transparent paper with a smooth, fine surface texture. Used to trace the outlines or dimensions of flat graphic materials placed beneath it. This material also has many other uses in retouching and graphic areas.

2
Masks, Stencils, and Friskets

CHAPTER 2

As noted in Chapter 1, black or white phototape can be used to mask or shield the mounting board and other surfaces from being soiled during the retouching process. The same principle applies to the image area as well. Even extensive retouching will usually consist of one or more localized and separate (even if bordering) areas. A tone or pattern applied on one part of the image may very well ruin another if it is allowed to infringe on that area. For instance, you may wish to darken a shadow area of a scene but do not want the darkening effect to extend to an adjacent area which is light. While airbrush and other methods of color application are fairly accurate, frequently very precise means of limitation is needed, and thus stencils, masks, or friskets are used.

Masks and stencils, while both having the same function of shielding specific areas of the image, approach this function from opposite directions. The mask is a shield, *around* which the retouching takes place leaving the masked area untouched. A stencil is a shield *within* which retouching takes place, leaving the surrounding area untouched. This is shown in Fig. 2-1.

Masks can be produced in several ways, and can also work

Stencil Mask

Figure 2-1. A stencil covers the whole image area with an opening for the retouching to take place in. A mask protects one area while leaving the rest of the image to be worked on.

in conjunction with stencils. There are two types of masks; liquid, and solid (acetate or paper). Liquid mask is a commercial product available from graphic or art supply firms under several brand names, all of which function similarly. Liquid mask is a substance that is applied to the surface of the print or the acetate overlay, covering the area to be protected, and drying to a gently adhering skin which will not allow retouching paints to penetrate. It can be applied with a soft, fine brush, or to larger areas, with a cotton swab. After application your brush should be thoroughly cleaned in accordance to manufacturers instructions (in soap and water, or a recommended solvent) to avoid ruining it. Some masking liquids contain coloration (usually red) which helps you to see the area you are covering. Rubber cement is not suitable as a masking medium as it is too thick to apply accurately, and the presence of thinner or solvent can damage the emulsion or acetate overlay surface. See Fig. 2-2.

As the masking fluid will begin to dry and clog the application brush which will sometimes happen when covering an intricate area over a longer period of time, it is a good idea to dip the brush in water, and gently rub the bristles on a bar of soap before dipping in the masking fluid. After the retouching has been completed, the liquid mask can be removed by gently rubbing the area with a pencil eraser, or a rubber cement pickup. If you apply masking fluid on the emulsion surface of a

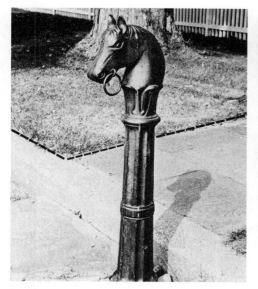

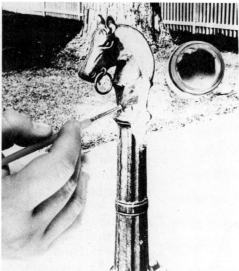

Figure 2-2. (a) In this photograph, the upper background (behind the head of this old hitching post) is too dark and distracting. The background will be retouched with a light, semi-transparent tone.

(b) Apply liquid mask solution to areas that are not to be toned. In this case, that will be the hitching post and the lower part of the background.

(c) Rest the hand on a protective paper sheet and air-brush in the desired tone.

(d) The final toned background print with masking solution removed.

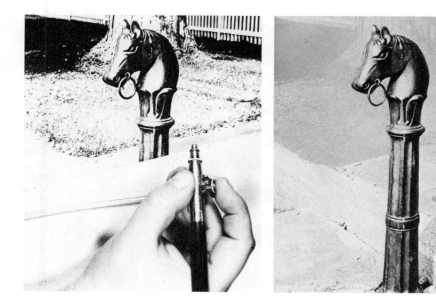

print, do so in a thin, even coat. Too much fluid can cause the masked area to buckle, or lift, leading to problems when the mask is later removed.

LARGE MASKS, AND STENCILS

To cover and shield large areas of a print surface, a sheet of acetate, cut to size, should be used. To produce a large mask, place an overlay of acetate over the print surface. Then trace the area outline in a continuous, smooth motion with a single-edge razor blade, stencil knife, or X-acto knife, gently cutting or deeply scratching the acetate (without cutting all the way through.) When this is accomplished, remove the overlay and separate the cut areas from the main sheet by gently folding the acetate along the cut lines, causing it to fracture and break cleanly apart. Rough edges can be trimmed with a scissors, or smoothed with a small piece of fine sandpaper. The process is shown in Fig. 2-3.

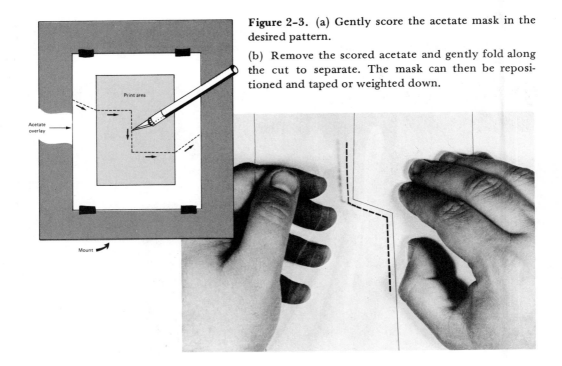

Figure 2-3. (a) Gently score the acetate mask in the desired pattern.

(b) Remove the scored acetate and gently fold along the cut to separate. The mask can then be repositioned and taped or weighted down.

The mask overlay is then realigned on the surface of the print and held in place with phototape and/or small weights. The three most important points of this method are: 1) be very accurate when outlining with the knife or blade, the area which needs protection; 2) be very careful not to cut through the acetate during the tracing procedure, as this can severely damage the emulsion surface; and 3) to accurately realign the mask on the image after separating it from the main sheet. This masking method can also be used in conjunction with an acetate overlay sheet, producing similar results, and still retaining the original print intact. See Fig. 2–4.

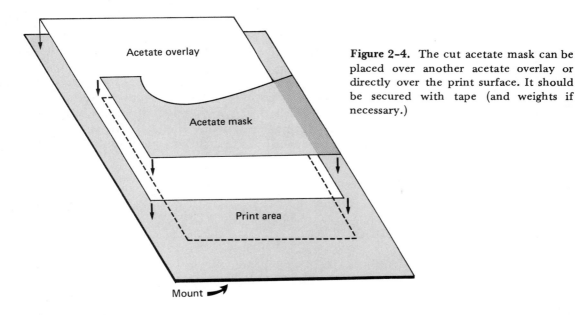

Figure 2-4. The cut acetate mask can be placed over another acetate overlay or directly over the print surface. It should be secured with tape (and weights if necessary.)

Acetate masks do not work well on small areas (which can be covered by masking fluid) because there is no dependable method of adhering the mask to a print or acetate surface. In addition, air-brush spray pressure would cause the edges of such a small mask to flutter, allowing the spray to penetrate beneath the mask; so when in doubt, use masking fluid. See Fig. 2–5.

When air-brush retouching over an acetate masked large area, hold the brush at a slight angle (aiming the nozzle towards the top of the print) and always work with the air-brush body over the masked area (to remove the danger of the spray pres-

Figure 2-5. Do not use small acetate masks as they flutter in the air-brush stream, causing smudged edges. It is better to use masking fluid.

sure lifting the untaped area of the mask, and spreading into the shielded area). See Fig. 2-6.

A stencil is necessary when only a small localized area of the print image needs to be retouched, and the rest of the image must remain untouched. Cut the stencil the same way as the acetate mask; tracing and cutting the shape of the area, and then folding along the lines to achieve separation from the main overlay sheet. See Fig. 2-7.

Figure 2-6. (a) A correct position and angle at which to hold the air-brush while retouching.

(b) This is a poor air-brush angle as it will lift the edges of the acetate mask. If the brush must be held this way, make sure the mask edges are securely weighted down.

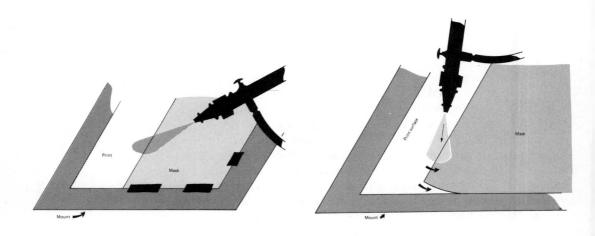

Figure 2-7. A stencil can be made of acetate, paper, cardboard, or frisket paper.

 If the stencil is large or intricate place small objects or weights (such as small bottles or small pieces of metal) to hold down the stencil edges, and keep the airbrush spray from lifting the stencil and contaminating other areas. You can also use your hand if necessary to accomplish this. These techniques are illustrated in Fig. 2-8.

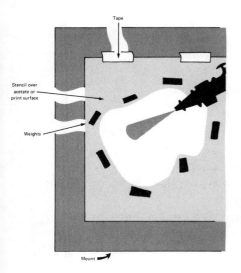

Figure 2-8. (a) The stencil cut-out edges can be held down by small weights.

(b) The stencil edges can also be held down by hand.

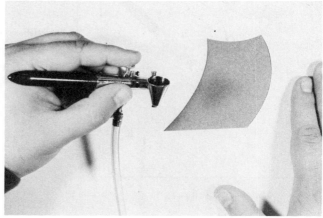

The air-brush should be held directly over the stencil cut-out area, and pointed straight down as much as possible during the retouching process. Experience and trial will show how far away from the cut-out area the air-brush should be held to minimize the risk of lifting the stencil edges with the spray.

If the stencil cut-out needed is very small or highly intricate, a combination of masking fluid and stencil can be used. First (whether on the print emulsion, or an acetate overlay) outline the stencil area with masking fluid, extending away from the area in an outline. Then cut the stencil to fit the extended area and provide a shield for the rest of the image area. See Fig. 2–9.

Make certain that the stencil cut-out overlaps the masking fluid area sufficiently to insure that the spray from the air-brush does not penetrate beneath the overlay (Fig. 2–10). Hold down the overlay stencil, after alignment, with phototape at the edges, and by hand or with weights near the cut-out area. After the retouching process, first remove the acetate stencil overlay, then the masking fluid by the recommended methods.

Figure 2-9. To protect the rest of the image while working on a small, localized area, first apply liquid mask.

Figure 2-10. After the mask has dried, cut an acetate (or other material) stencil to overlap the masking solution outline.

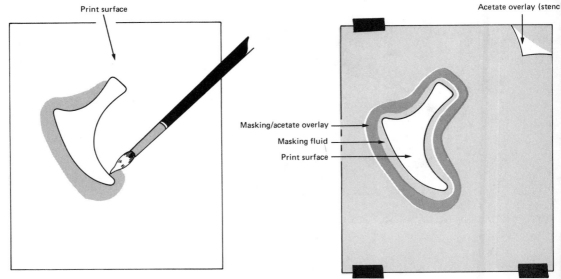

Print surface

Acetate overlay (stenc

Masking/acetate overlay

Masking fluid

Print surface

Applying liquid mask

Cut acetate stencil taped over masked print

Figure 2-11. The raised mask or stencil.
(Note the clear area.)

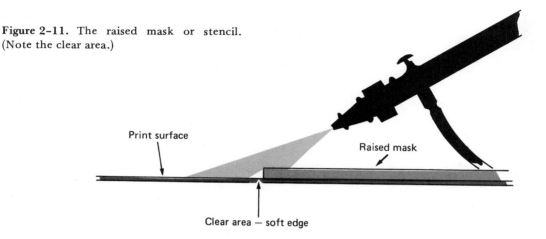

Print surface

Raised mask

Clear area — soft edge

FRISKETS

Although some brands of masking fluid are referred to on the label as liquid frisket, they should not be confused with frisket paper which is an entirely different product using the same basic principle. Frisket paper is available in sheets and rolls. It is usually quite thin, and delicate to handle. There are two main types of frisket paper. One kind has to be coated with rubber cement by the artist, the other is already coated with a pressure activated adhesive (which sticks when burnished down with a smooth surfaced tool.) Frisket papers have a short shelf life, and become brittle and ineffective after a relatively short period of time. There are no retouching problems in which masking fluid and/or acetate stencil cannot be substituted for frisket paper. The use of frisket paper is generally considered out-moded in the retouching of photographs although it still retains some uses in illustrative and mechanical drafting in which the air-brush is used as a method of adding tonal details. Other types of paper and cardboard can also be used as stencils and large area masks. The thickness of the masking material influences the type of edge produced when the air-brush sprays into the area. Thick stencils or masks (sometimes referred to as *raised* masks) produce a softer edge or outline because they diffuse the spray causing a slightly uneven area of application. See Fig. 2-11.

This effect can be of great value to the retoucher when correcting photographic image areas which do not have clear, sharp outlines and need soft-edge tonal changes. Experimenting with various types and thicknesses of paper and/or cardboard will produce a vocabulary of different effects for the retouching artist to draw upon to solve the various problems that each job presents.

GLOSSARY

BURNISHER A tool used to apply pressure and rub-down graphic materials. Usually a flat, polished piece of wood, plastic, or bone, burnishers are used to apply pressure sensitive type, decals, or push out air bubbles when two materials are being bonded with a liquid glue such as rubber cement.

FRISKET A term sometimes applied to liquid masking solution, called *liquid frisket*. *Frisket paper* is a thin, delicate material which is sometimes used in retouching, and graphic design, and is available in sheets and rolls. This material has generally fallen into disuse with retouchers as it is difficult to store and use.

MASK A shield which keeps an area on the print image clean when surrounding areas are being retouched. A mask can be made of paper, acetate, or liquid masking solution.

RAISED MASK A mask cut out of a thick material such as mat board, heavy cardboard, or paper which because of its thicker edges produces a soft, diffused edge rather than a sharp edge when used in conjunction with the air-brush.

SHELF-LIFE The period of time a material can be stored before it looses its effectiveness, or otherwise deteriorates.

STENCIL A shield which surrounds the print area being retouched and keeps it clean by confining the retouching process. Stencils can be made of paper, acetate, or liquid masking solution.

STENCIL KNIFE A short pen-like handle with a sharp cutting blade set in one end, used for cutting stencils out of paper, acetate, and other thin materials. Some stencil knives have a blade that swivels in different directions during use that makes cutting curves or intricate patterns much easier.

3
Retouching Colors for the Black and White Print

CHAPTER 3

Retouching colors are packaged in two basic forms: tubes and pans. Sets of retouching colors are available, arranged in order in dry tablets set in pans (similar to water-color sets), and usually in a folding metal or plastic box which doubles as a mixing tray. These colors (which mix with water) are primarily meant for hand retouching of small flaws in the print image with pointed sable water-color brushes (size 5 zero and up). They can, however, if prepared in larger amounts with a bigger water-color brush, be used in the air-brush. By mixing more water in a pan, the resultant larger quantity of color can be transferred to the air-brush cup, a brush-load at a time as can be seen in Fig. 3–1.

An additional advantage of the pan-type retouching sets are that they frequently include both a glossy and a matte finish black, warming, and cooling tones (infrequently used but good to have available), a film opaque paint (used in retouching negatives), and even a print cleaner. The kits will also include a tube of opaque white paint, two or more small fine pointed brushes, and a retouching pencil (which has rather limited uses in retouching). The retouching colors (in both pans and tubes) come

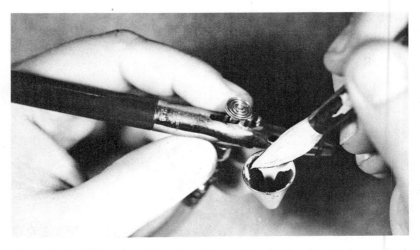

Figure 3-1. Filling the air-brush color-cup by the brush-transfer method.

in six tone increments. Tone 1 is a pale gray (the nearest commercially made tone to white) and scale down to 6 (the nearest commercially made tone to black). Pan type colors are shown in Fig. 3-2.

Frequently, it is necessary to have a shade of retouching paint which is either lighter than 1, darker than 6, or somewhere between the increments offered. To produce mixtures of tone that better match the color needed in an image area, handle the retouching colors as watercolors. The type of paint used in retouching must be extremely opaque (being as non-transparent as possible) to insure that the flaws, or whatever is being altered in the image does not *ghost* or show through the retouching paint. When mixing tones which are a combination of other shades, always be careful not to mix the paint too thin and watery. Paint which is too thin will dry semitransparent, and will be extremely difficult to work with.

The pan retouching colors are meant primarily for small area retouching (for which large quantities of paint are not necessary) and are designed for easy use with small brushes. (The technique for manual retouching with small brushes is detailed in Chapter 4.) Retouching colors are available also in tubes, which facilitate the rapid mixing of larger quantities of color. Tube colors (like the pan colors) are manufactured in increments from number 1 through number 6, with opaque white and black also available. Because these colors are already

semiliquid, they can be mixed quickly in the larger quantities necessary for air-brush retouching without the risk (inherent in the smaller amounts of color available from the pans) of running short and having to remix, and rematch a tone in the middle of a job. With the aid of a number 2 or 3 watercolor brush, small amounts of color can be taken directly from the tube mouth to be mixed with water in the air-brush cup, in a separate container, or on the palette surface. Since tube colors are usually of a fairly thick consistency, be sure when mixing them with water, or each other, that there are no lumps of unmixed paint present when you begin work. Unmixed particles of paint can clog the air-brush or, if small enough to pass through the brush, produce sudden, unwanted color changes. An excellent container for both mixing and storing colors is the air-tight plastic cans in which 35 mm film is available. As these containers are usually discarded after the film is used, retouchers can frequently arrange for a supply of them to be made available. If you decide to use a container of this type to store extra color in be sure the cap is on tightly during storage (to prevent evaporation) and also thoroughly mix the paint again with a

Figure 3–2. Retouching colors in pans in a palette tray.

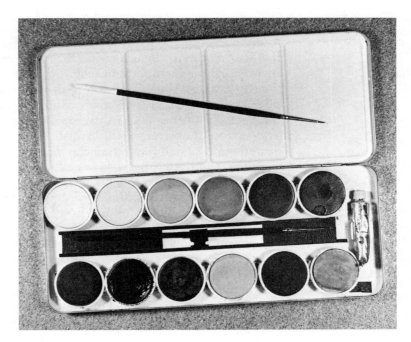

Figure 3–3. Plastic 35-mm film containers are useful in storing mixed paint. (Labels can be placed on each for identification.)

watercolor brush before using (as it will have a tendency to separate and settle during the time it is stored). See Fig. 3–3.

The mixing of retouching colors is an eye skill which is best learned through experience and experimentation. Whether matching a tone is required, or preparing a lighter or darker tone for an area, try holding a brush full of the mixed color over the area to be worked on (thus by comparing it to the surrounding tones, you can see how close your mixed color is to the tone required). Bear in mind that some retouching paints dry slightly lighter in tone than when in a wet state and some dry slightly darker. This is not too critical when working on an acetate overlay. (If a gross error is made, simply clean, or discard the overlay and begin again.) When working on the actual emulsion surface, however, extra care should be exercised (since repeated removal and repainting can injure the emulsion).

There are two basic types of image tones in the photographic prints. The retouching colors described so far are designed for use with *cold-tone* prints (the most common type of print paper in use). There are, however, a variety of *warm-tone* print papers in use. These papers have either a greenish-black or brownish-black image tone. In the retouching of such a print, ordinary colors (meant for cold-tone papers) will not function properly, and an additional coloring agent will have to be added to the paint before application. As mentioned earlier, the pan-set of retouching colors includes a warming, and a cooling color. These tones may also be acquired in tubes, for mixing larger amounts of color. For retouching, mix the shade (light or dark)

that is needed with the regular retouching colors, then add a small amount of the warming or cooling tone until the paint shows the proper color shift to match the general print tone. Here again, experimentation and trial will provide more confidence and accuracy as familiarity with methods of solving particular problems increases.

suggestions

Try out different manual and air-brush retouching methods (especially in color matching) on spare or surplus prints. When practicing mixing retouching colors, do so on a white tray, or surface as this will influence the tone you see less than a gray, black, or colored surface. Always hold a brush full of color over the area of the print you will be working on to compare it to surrounding areas as a test of accuracy.

When preparing and mixing larger quantities of retouching paint, or retouching a large area on the print, add a small amount of *noncrawl* or *flexible paint* agent. These products (available under a number of brand names) are liquid additives which inhibit wet paint from shrinking or spreading and adds a

Figure 3-4. A squeeze bottle water jar is useful for mixing paints and clean-up.

flexibility to the paint to discourage chipping and flaking. These products do not have to be used together, and some newer products combine both actions in one solution. Always be sure to have a source of clean water available. A large jar or squeeze bottle of water and several containers for washing your brushes and other tools in is required. Accurate and neat retouching is impossible without a scrupulously clean work area and tools. See Fig. 3-4.

REMOVING RETOUCHING
COLORS—ACETATE OVERLAYS

A primary point to remember in this process is to be very gentle and very complete. Since the retouching paints discussed so far are water-based, they can be redissolved by water and removed from either the print emulsion surface or an acetate overlay. Removing paint from acetate overlays is not as critical as on a print surface because the acetate surface beneath the paint is waterproof. Accuracy, of course, is important if there are other areas of retouching on the overlay that must be preserved. Thoroughness is required to insure that the last vestiges of paint are removed from the area that is being cleaned. Cotton swabs or (for larger areas) cotton balls can be used for this procedure. These absorbent cleaners should be wet (but not soaking) with a few or more drops of water. An eye-dropper is ideal for con-

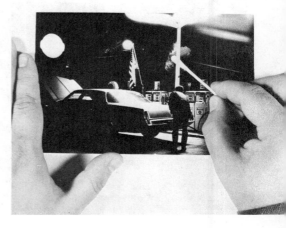

Figure 3-5. (a) Using a cotton swab to remove unwanted paint from acetate or the print surface.

(b) A cotton ball can also be used to remove paint or blot up excess water on the acetate.

(c) Blotting the cleaned acetate area with a piece of clean tissue.

trolling the water content of swabs. Remove a small area of paint at a time with a gentle back and forth or circular motion. Change to another swab as soon as one becomes soiled. (If not, the paint will start to be reapplied to the surface.) Do not allow water to run or bead on the surface. The last vestiges of paint on an acetate surface are usually in the form of a very thin film. This may be removed with a slightly damp swab followed by a final blotting with a clean swab or soft tissue. After allowing the surface to dry a few minutes, the area can then be repainted. Very small or intricate areas on the overlay can be cleaned with a slightly wet, fine pointed brush (washed very frequently) and blotted with a slightly damp swab followed by a final blotting with a clean dry swab or tissue. See Fig. 3–5 and 3–6.

Although the cleaning process is a difficult and laborious one, it is a better practice than attempting to overpaint a mistake. Too many layers of retouching paint, even on a small area, are much more likely to be prone to chipping, flaking, or cracking, during handling.

REMOVING PAINT FROM THE PRINT SURFACE

When removing retouching paint from the actual print surface, great care should be exercised in keeping the surface from becoming too wet. Water will penetrate the emulsion layer of the print if allowed to be in contact too long. This causes a

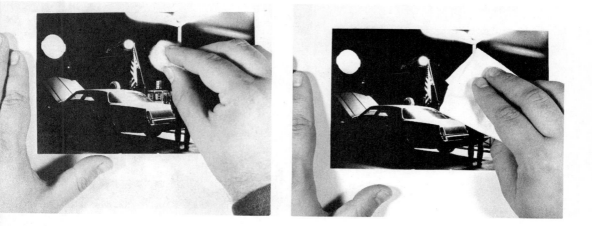

Figure 3-6. (a) Small or intricate areas on the acetate or print surface can be cleaned with a small damp brush. Be sure to wash the brush frequently.

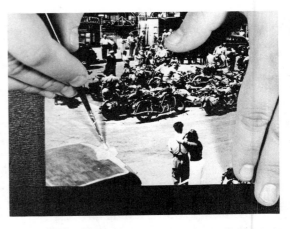

(b) A cotton swab can also be used to clean smaller areas.

(c) A tissue can be used as a final blot on acetate only.

softening effect which can peel the area off the backing beneath it. If emulsion softening takes place during the cleaning process, it can cause particles of paint to become imbedded in the emulsion, making them difficult or impossible to remove. Additionally, a soft emulsion area will be sticky, producing snags, and trapping cotton fibers from the cleaning swabs, in the surface. Therefore, speed and accuracy are necessary in this cleaning procedure. A damp swab or cotton ball should be used. However, do not rub back and forth over an area more than three or four times unless absolutely necessary as the risk of damaging the emulsion is always present. A circular motion or light strokes will usually remove all but the heaviest paint layers. After the last vestiges of paint are removed with a damp swab, do not blot the area, but allow it to air-dry for fifteen to thirty minutes (longer if it is a damp day, with very humid air). When the area is completely dry, it can be repainted without any further preparation.

suggestions

Frequently, commercially manufactured cotton swabs are too soft or loosely woven, and cause problems by "shedding" fibers during the cleaning process. This effect can be minimized somewhat by tightening the tip of the swab by holding it with the tips of the fingers and rotating the cardboard or plastic shaft in one direction or another until the tip packs tight. See Fig. 3-7.

Figure 3-7. Tightening the tip of a cotton swab by rotating the cardboard or plastic shaft.

Figure 3–8. (a) To make a hard-point swab, begin by sharpening a brush handle or wooden stick.

(b) Feed a few strands of a small piece of cotton to the tip while continuing to rotate the stick or handle.

(c) Continue rotating and winding the tip until the cotton is rolled tight.

A swab can be made by sharpening the end of a thin stick, or brush handle, and tightly winding some long fiber cotton (such as is sold for bandages) around the end by rotating the shaft. This material is generally not as absorbent as the commercially produced swabs, but will do if others are unavailable; additionally, the home-made swab can be made pointed (by winding the cotton thinly around the sharpened shaft) and used in intricate or very small areas where blunt swabs cannot reach (as shown in Fig. 3–8).

A fine pointed water-color brush can be used to remove paint from the emulsion surface also. This technique is well suited to cleaning the edges of the area, but be careful not to go over the same place too many times. Use the brush point to loosen and dissolve the paint, then use a damp swab to remove it.

GLOSSARY

COLD TONE The basic color structure of a type of a black and white photographic paper. Many modern print papers are cold tone, having a blue–black basic color structure. These papers are among the most commonly used in art and industry.

EYE DROPPER A very useful tool in paint mixing, print cleaning, and any area of retouching that requires exact amounts of water. The best eyedropper for these uses is the kind which is part of the screw top of a small bottle, and has a fine, narrow point.

FLEXIBLE PAINT MEDIUM A liquid additive mixed in small amounts with ink or retouching paints to make them less susceptable to cracking, shrinking, flaking, or adhering improperly to acetate, or the emulsion surface of a photograph. These products are available under a number of brand names, and some products combine both actions in one solution, paint flexibility and improved paint adhesion.

GLOSSY AND MATTE FINISH These terms refer to the light reflecting qualities of a surface. Photographic print surfaces can have a high gloss, semigloss, or matte surface. Seen at the proper angle a glossy surface will reflect a great deal of light (similar to a glass plate). A matte surface will absorb light and diffuse it to produce a dull, seemingly soft effect. Glossy and matte are also used to describe dry retouching paint surfaces.

OPAQUE Opaque materials and paints are dense and cannot be seen through. Retouching paints are opaque so that they can conceal flaws, or alter the tone of an area without the underlying portion showing through.

PALETTE A surface or tray on which paints are mixed to achieve the desired color or shade. There are many different kinds and styles of palettes for a variety of needs.

RETOUCHING COLORS Sometimes called "retouching grays," these water-soluble paints are available in either hard tablets (as with watercolor sets) or as a liquid (in tube form). In addition to black and white, there are a series of grays of varying shades. These, depending on the intensity of the shade, are numbered 1 (at the lightest) to 6 (darkest). These paints are used in conjunction with regular brushes as well as the air-brush.

SINGLE-EDGE RAZOR BLADES Difficult to use, but a very handy tool. Because these blades are inexpensive and disposable, they are frequently preferred by retouchers to more expensive "knife" type blades, especially for nonintricate cutting work on heavy cardboard and acetate.

43

WARM-TONE Some specialized photographic papers, or processing, produces a different basic color structure. The warm-tone image color is usually brownish-black, or greenish-black. Many professional portrait photographers use warm-tone black and white papers.

4
Black and White Spotting Techniques

CHAPTER 4

Sometimes referred to as *manual* retouching, these non-air-brush techniques are primarily concerned with correcting flaws on the emulsion surface rather than changing the larger image. The color source in these techniques is a penetrating dye, manufactured to coincide with the basic tones present in popular printing papers. These colors (such as Spotone brand) are produced in the basic dark tone and are lightened to the needed tone by dilution with water. The best application method is with a very small (triple or double zero) pointed water-color brush (sable is preferable). The type of flaws most often encountered which require spotting are white streaks or shapes caused by dirt, hair, or other debris adhering to the soft emulsion surface of a photographic negative before or during drying. Since these foreign objects stop light from passing through the negative area they block during enlarging, their shape shows up, in white, greatly enlarged on the actual print image. Since the spotting colors described are dyes which soak into the emulsion of the print, they have a cumulative effect, meaning that a darker tone can be achieved by going over an area more than once to build up color. This method will better insure a soft-

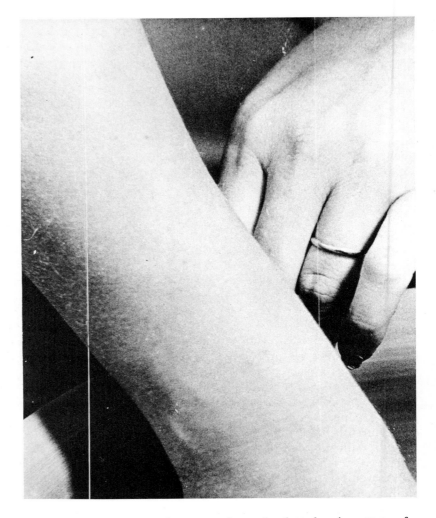

Figure 4-1. An extreme enlargement shows the dotted grain pattern of a photograph. How much grain a photographic image has depends on film type, enlargement, and processing.

edged area of retouching, and working from light to dark lessens the chance of producing a dark spot which will have to be removed.

Begin by diluting some color until it produces a shade definitely lighter than the area to be retouched. Put some color on the brush (do not overload the brush) and work the tip to

a fine point, removing excess color on a scrap of paper. Since most photographic prints have a tiny, but visible grain, the object when applying the color is to match this pattern as much as to match the tone. See Fig. 4–1.

A good quality magnifying glass (of three or more power) aids greatly in this procedure. When a retouched area appears acceptable through magnification, it is sure to be acceptable when seen in a less enlarged state by the naked eye. The best method of matching the grain of the print is to use a *dotting* technique of gently touching the tip of the brush to the area again and again to build a tone. For this retouching technique, the print surface is usually not dry scrubbed as described in Chapter 1. However, if the dye does not seem to penetrate properly during the dotting action, allow the brush tip to pause in contact with the surface a little longer. Recolor your brush as soon as it begins to run out of paint since these dyes must be wet in order to properly function.

A slight rotating or circular movement of the brush tip while in surface contact will also aid in color penetration. See Fig. 4–2. If the print emulsion is very glossy, or very hard (due to the way it was processed by the printer), mix a quarter teaspoon of sodium carbonate in a quart of water. Apply this to the surface of the retouching area with a swab or cotton ball, blot up all the excess fluid and then proceed with the retouching. Retouching dyes such as Spotone brand are packaged with extensive and complete manufacturers' instructions, and these should be studied thoroughly. As with the opaque retouching colors discussed earlier, spotting dyes will dry to a slightly different tone and shade than when wet. Spotone for example, dries slightly darker and warmer than when wet. Experience with these materials will supply information as to the reaction of shades placed on the surface, so that accuracy can be achieved. Removal of these dyes can be achieved by the use of a solution of a few drops of ammonia (four to eight drops) in four ounces of water. Apply with a fine brush, a little at a time and blot with a swab to achieve a gradual lightening effect. When the desired shade is reached, be sure to clean the area with a small amount of water (on a swab) and gently blot up any excess. As with opaque retouching paints, products as Spotone are available in different tones (for greenish-black and brownish-black print emulsion types as well as many others) and can be intermixed to tailor the color tone necessary for a particular job. For standard cold tone prints

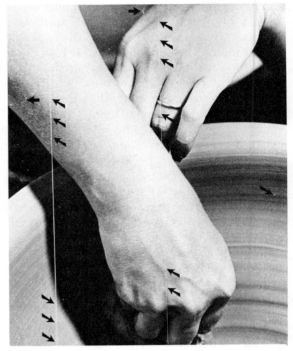

Figure 4–2. (a) White lines, marks, or irregular shapes caused by dust or other contaminants frequently appear in the enlargement. Here straight, light streaks will be retouched, as well as assorted smaller flaws.

(b) Applying the mixed spotting dye with the dotting technique. A magnifying glass is a helpful aid.

(c) The finished areas should blend smoothly into the surrounding grain pattern.

(most commonly used), Spotone number three works very well alone. However, extensive instructions and charts are supplied by the manufacturer to cover virtually all variables in tone color that are likely to occur.

Ideally, proper processing of the negative including drying it in a dust-free environment (by the processor) will insure a very clean image when enlarged. However, during storage, negatives do pick up dust and other debris which, even though they are usually dusted before enlargement, can cause marks or flaws to show up in the printed image. Additionally, dust and dirt on the surface of the enlarger optics (condenser and enlarging lens) can cause both sharp and blurry shapes to show up, causing additional need for retouching. While these problems in photographic printing are usually not the direct concern of the print retoucher, a clear understanding of the causes of such difficulties can aid in determining an approach to their correction. It should be noted that the use of spotting dyes for minor correction does not show up on the print surface (opaque

retouching colors have a matte texture), and because the dyes
become part of the emulsion they are just as flexible as the
print itself. When performing major retouching with the air-
brush on an acetate overlay, minor print flaws can be corrected
on the acetate with the opaque paints, and a fine brush in the
dotting method described for spotting dyes. Working with the
negative image prior to enlargement printing will be covered in
Chapter 11.

GLOSSARY

ENLARGER OPTICS A photographic enlarger is basically a projector
equipped with focusing and light controlling mechanisms which allow
manipulation of the projected negative image and, ultimately, the positive

print produced. The enlarger optical system usually has two primary parts; the *condensers*, a set of two or more large plano-convex lenses which modify and intensify the light passing through them from the light source to the negative. The *enlarger lens* is a lens system with an adjustable iris to control the amount of light in the projected negative image. The optic series in the average enlarger would be: light source to condensers to negative to enlarger lens and then projection to a print paper.

GRAIN STRUCTURE When a negative is enlarged many times to produce a photographic print, the light sensitive materials of the film (which hold the actual image) are also magnified. The larger the magnification, the more apparent is the grain pattern or structure of the negative. In addition, different types of films, as well as processing chemicals and techniques produce more or less pronounced grain structures.

NEGATIVE FLAWS A number of marks, lines, or shapes caused by dust contaminants and chemical or water impurities that become part of the photographic negative. These dust particles or shapes will usually show up on the positive print image in white.

SOFT EDGE When referring to parts of the photographic image, soft edged areas are characterized by smooth blending into surrounding tones. This tone change is gradual, and produces no sharp delineations between dark and light areas.

SPOTTING DYE A water-based, dark tone dye which is used directly on the emulsion surface with a small water-color brush, to make minor corrections of usually light colored flaws. This material, which dilutes to any desired shade, penetrates into the print surface and becomes part of it.

WATER-COLOR BRUSHES Long handled brushes, usually made of a quality fur such as sable, and distinguished by the fine point which can be achieved by manipulating the wet brush. These brushes are available in a number of sizes ranging from quite large, to a triple or even five zero which literally contains only a few dozen hairs. With proper care in washing and storing, these tools can last for years.

5
Silhouetting in Black or White on Black and White Prints

CHAPTER 5

A process that is extensively utilized by advertising agencies, catalogers, and the printing industry in general (and that should be thoroughly familiar to professional retouchers) is *silhouetting*. To silhouette means quite simply to outline, to isolate, or to separate one area or portion of the photographic image from the rest of the image. This process is valuable in product photography where a pure white or black background is required. It is also useful in separating the images of persons or objects from backgrounds against which they may have had to be photographed, but which detract from or confuse the purpose of the photograph.

Silhouetting can be performed on either the print surface, or on an acetate overlay, but for reasons which will become apparent, it works best on the actual print surface. The print should be properly mounted and dry scrubbed or coated with print preparation fluid (as described in Chapter 1). The paint color will be pure white or black opaque retouching color (mixed from a tube, or prepared from a commercially made opaque paint available in small jars). The paint should be of a medium thickness; if too thin, it will run or bead on the surface.

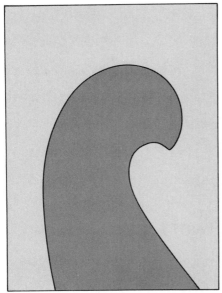

Figure 5-1. (a) In silhouetting, the main subject area is separated from the rest of the image. Here the dark curve is to be separated from the background.

(b) A white outline has been employed.

(c) A total white background has been applied.

(d) A black background has been employed.

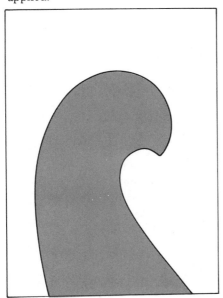

56

If it is too thick it will build up and crack, and will be hard to control when covering intricate areas. A drop or two of no-crawl or flexible paint fluid should be added to the paint (if it is not already mixed in, as it is in some commercially prepared products). Tempera, or poster paints, though suitably opaque, and inexpensive, should be avoided by the retoucher in this situation as they are not flexible and will crack and flake when dry.

When receiving a print for silhouetting, the retoucher should first determine exactly what part is to be outlined, and clear up any questions about the image before work begins (so that no time is wasted later in removing mistakes, and redoing areas). Next, the retoucher should determine whether a total color background or just an *extended outline* is required. An extended outline is sometimes all that is necessary when a printer is to make a plate or reproduction of the image. This type of outline is a 3/4 inch (approximately) area of white or black around the subject, leaving the rest of the image to be screened out by the printer. See Fig. 5-1.

The extended outline takes somewhat less time to prepare than a total color background. If it is all that is required, knowing that can be a valuable aid to the retoucher in situations where time is at a premium and deadlines must be met.

The total color background is a silhouette where the white or black background extends from the subject area to the edges of the image area, completely covering the background of the original photograph. As mentioned earlier, silhouetting works best when done on the actual print surface (because very sharp outlines are necessary for proper reproduction during rephotography and printing). However, a total color background involves much more area. This work may be done on an acetate overlay with the air-brush. In this case, the area to be silhouetted should be covered (very accurately) with masking fluid, then a flat tone of white or black may be sprayed over the entire area. Techniques of silhouetting are detailed in Fig. 5-2 through Fig. 5-6.

When using this method, be very sure that the acetate overlay is securely taped down, and will not shift during transit to the photographer or printer (as this can result in a ruined image if it is not noticed before the print goes into production). Silhouetting methods can also be applied to the photographic negative prior to printing, which will be detailed in Chapter 11.

Another extended outline method available to the retoucher is a paper mask background. This method is superior

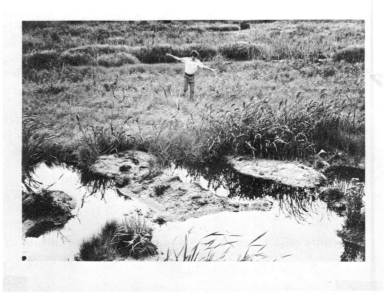

Figure 5-2. In the original image, the upper portion above the figure must be silhouetted white with a background that extends to the upper edge of the print.

Figure 5-3. (a) An acetate overlay is taped down.

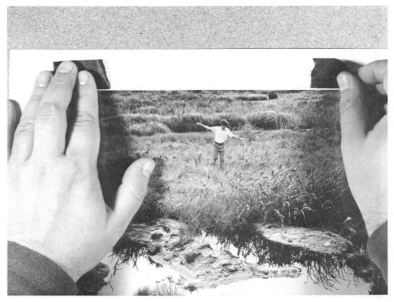

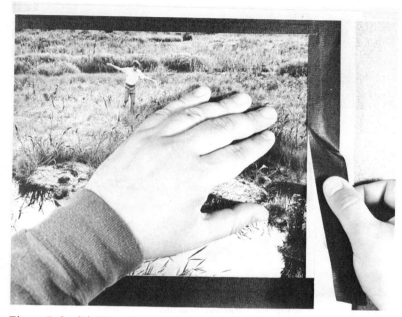

Figure 5-3. (b) The edges of the print area are established with strips of photo tape.

Figure 5-4. Masking solution is applied over the upper area across the print.

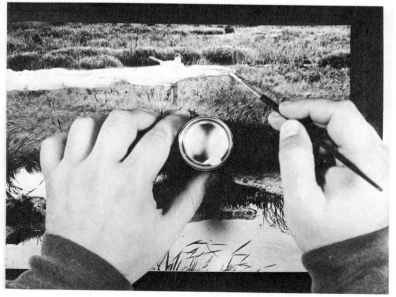

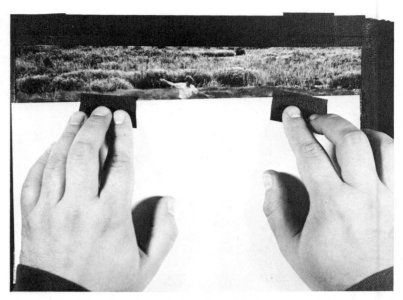

Figure 5–5. (a) After the solution has dried, a paper shield is taped down extending into the masked area.

(b) Keeping hands on the paper shield, a flat white background is applied with the air-brush.

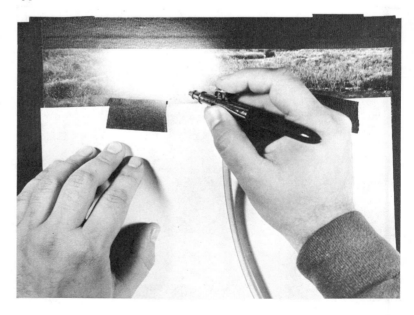

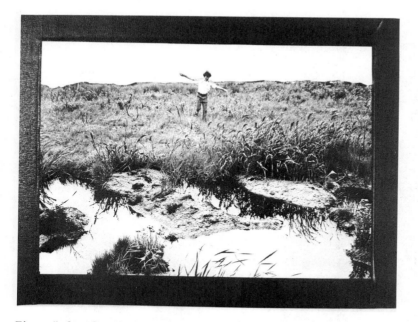

Figure 5-6. After the masking solution and paper shield have been removed, the tape can be removed or it can be left in place.

to the acetate total color background when the area being silhouetted is intricate or complex, or when the background area is very large and too time consuming to paint. (The acetate overlay background should only be used when the original print must remain untouched.) Silhouette the area in question with an approximate 3/4-inch outline and allow to dry thoroughly. Place a sheet of thin bond paper (sketching or layout paper) over the entire photograph, then lightly trace an outline which falls just within the painted silhouetted outline. Remove the paper and cut along the line with a stencil knife, or single-edge razor blade. Replace and realign the mask over the photograph, securing it along the top of the mount with a strip of phototape. See Fig. 5-7.

APPLYING STRAIGHT EDGES IN SILHOUETTING

It is sometimes necessary to produce a very accurate edge on the surface of a print being silhouetted. While retouching paint can be thinned enough to work in a ruling pen, this method is

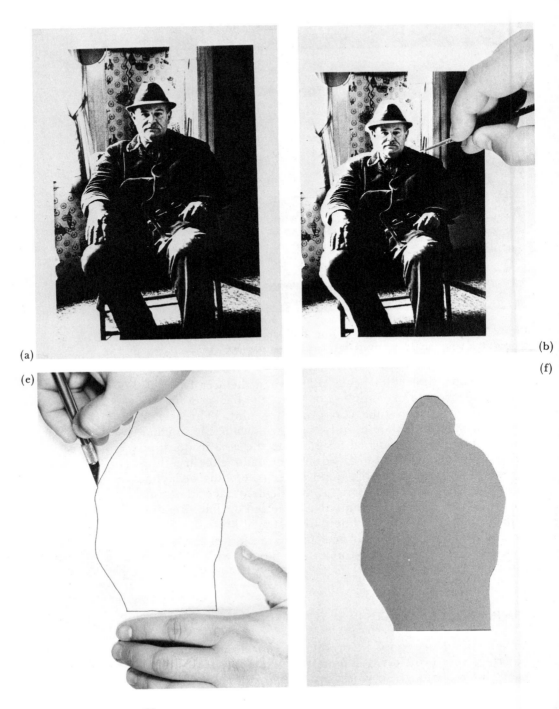

(a)

(b)

(e)

(f)

(c)

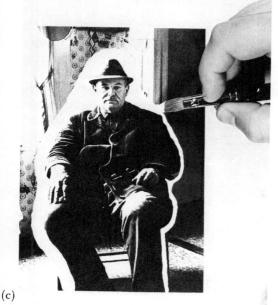

(d)

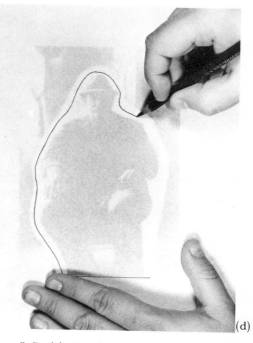

(g)

Figure 5-7. (a) In the original image, the figure is to be separated from the background.

(b) A thin white outline is applied to the area edges with a small brush.

(c) A larger brush is employed to extend the outline to one-half to three-quarters of an inch.

(d) A piece of tracing paper or other material is placed over the dry image and a line is traced (in blue nonreproducing pencil) around the image, within the silhouetted boarder.

(e) The outline on tracing paper can be taped over a sheet of opaque white paper and cut out with a knife or scissors.

(f) The finished paper mask.

(g) The mask is positioned over the silhouetted image and taped down at the edges to create a total color background.

messy, and prone to problems (as the thinned paint crawls and runs on the surface). A better method is the *cut-tape* process. First determine exactly where the straight edge is to appear upon the image. If the edge is to be parallel with the edge of the print (such as a horizon line would be), it is advisable to measure and mark (on both sides of the print) exact distances from top or bottom, as shown in Fig. 5-8.

Next, gently apply a strip of phototape across the print surface with the lower edge touching the measurements as shown in Fig. 5-9. The width of the tape should lie in the area which will be blocked out. Then using a metal edge ruler and X-acto knife or single-edge razor blade, gently cut a *wedge* from where the straight edge of the tape connects to the image to be silhouetted.

Be careful not to cut too deeply, as this can cause damage to the underlying emulsion surface. After cutting the wedges necessary, peel and remove the tape from the area in the center of the silhouette that is to be preserved, as shown in Fig. 5-10. The painted portion of the silhouette can now be added, connecting to the points of the wedges.

Then, if a total color background is needed, a paper mask (discussed earlier) may be employed to achieve this. This is illustrated in Fig. 5-11.

Vertical, and diagonal straight edges can be produced in a similar manner. Different tape widths should be tried to determine which is easiest to work with in more intricate areas. See Fig. 5-12 and 5-13.

Figure 5-8. (a) In this image a horizontal straight edge is to be applied along the dotted line and combined with a silhouette of the head.
(b) A T square is used to mark the mount on both sides of the image for the straight edge (use a blue, nonreproducing pencil.)

Figure 5-9. (a) A strip of white photo tape is applied, with the bottom edge aligning with the marks on the mount.
(b) A wedge is cut where the lower edge of the tape connects to the image.

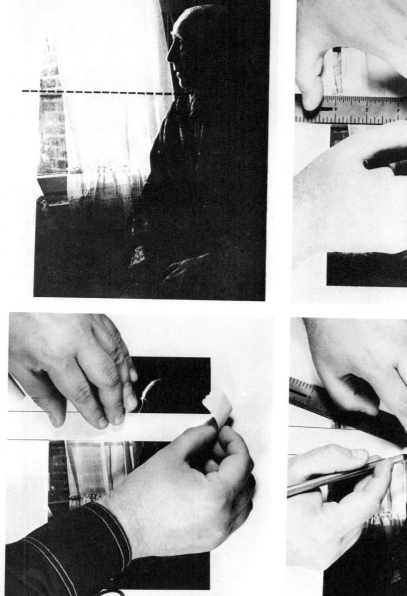

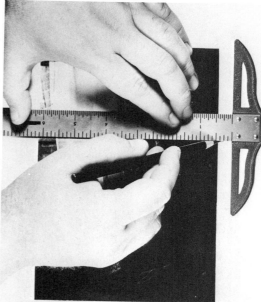

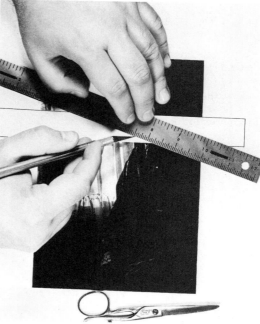

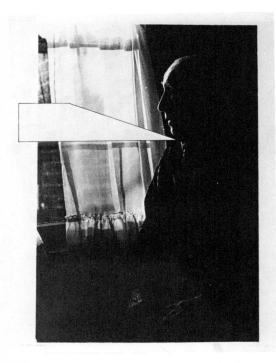

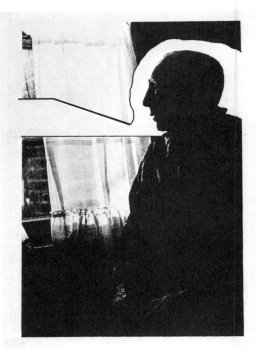

Figure 5-10. The wedge is shown outlined.

Figure 5-11. (a) The wedge connected to a silhouetted outline applied to the head. Note that the back of the head is established with the silhouette.

(b) The final silhouette.

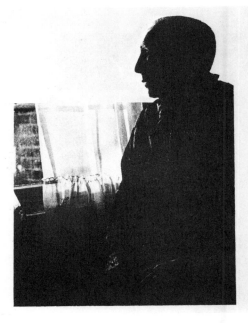

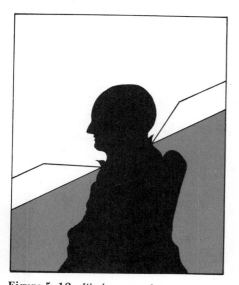

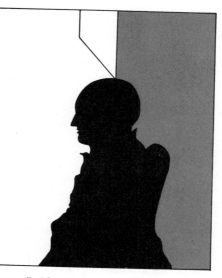

Figure 5-12. *Wedges* can be applied to both sides of an image and may also be applied diagonally.

Figure 5-13. *Wedges* can also be applied vertically to the image.

GLOSSARY

CUT-TAPE SILHOUETTE A method producing, with the use of photo tape, a sharp edge as part of a silhouette.

EXTENDED OUTLINE A form of silhouette where the part of the image to be isolated is outlined in roughly a 3/4- to 1-inch solid color area.

SILHOUETTING The process of outlining and isolating an image on the photographic print in either white or black, with opaque paint.

TOTAL COLOR BACKGROUND A silhouette where the white or black outline extends from the subject area to the edges of the total print image.

WEDGE Part of the cut-tape silhouetting process where a straight edge is intersected by another part of the subject area. At the point where the straight edge of the tape contacts the area to be silhouetted it is cut to a point to keep the tape from overlapping into the subject area to be preserved.

6
Paint Application–
Manual Retouching

CHAPTER 6

Having prepared the print surface, and mixed or prepared an acceptable paint texture, the actual silhouetting procedure can begin. Outline the edges of the area with smooth, flowing strokes, recharging the brush when the paint begins to run out. (A dry, or semidry brush will produce an unacceptable silhouette.) Do not blob the paint on an area, and then push it around. Apply an even coat, with a minimum number of strokes in any particular area. If the edges, or part of the subject that is being silhouetted are ill defined or unclear it will be necessary to establish an arbitrary outline based on the retoucher's decisions, or on specific instructions from other sources, if available. The key to successful silhouetting is a smooth, believable delineation of the outline. Curves should be clear, direct, and smooth with no apparent hesitation. Intricate areas should be sharp and decisive (Fig. 6-1), without sketchy marks or clumsy lines. Practice these applications procedures until a clear working approach and method can be established.

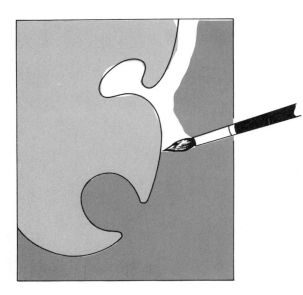 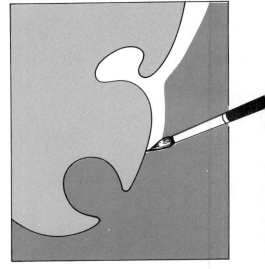

Figure 6-1. (a) When applying paint to an image surface, the strokes may be short—but the edge should be smooth. This is too harsh and broken.

(b) A correctly applied curve is smooth edged.

suggestions

Keep a supply of prepared silhouetting paint (in both black, and white) available in a sealed container. This will save considerable time in preparation, as only a quick stirring, or shaking will be necessary to prepare the paint.

Keep several brushes of differing sizes available for silhouetting jobs (a zero, a 2 or 3, and a 6 would be a good selection). Use high quality red sable watercolor brushes which can be shaped to a fine point. Always thoroughly clean the brushes after each use, and shape them to fine points before allowing them to dry upright. Never leave a brush standing in water or paint (Fig. 6-2) for any length of time as this will cause a misshapen tip, making the brush difficult to control.

Photographing objects or persons accurately, while trying to produce a flat, pure white or black background is difficult and time consuming. Many professional photographers rely on retouching services to provide the necessary print image alterations. Industry's demand for this process is also quite constant, especially in product, catalog, newspaper, and magazine layouts.

Figure 6–2. (a) When washing a fine brush, swirl it through the water. *Never* leave a brush standing for any length of time like this as it will bend the point.

(b) Reshape the washed, still wet brush to a fresh point by rotating it gently on the back of the hand.

(c) Store washed and reshaped brushes *upright* in a jar or other holder.

PAINTING THE EDGES OF CUT PHOTOGRAPHS

Frequently, layout artists are called upon to assemble images made from cut out parts of several photographic prints. These *montages* or *assemblages* are pasted down to produce a new composite image which is often used in advertising design. While the layout artist or art director usually chooses, cuts out, and arranges these designs, a certain amount of retouching is often needed before and after the tacking down of the parts. When an area of a photograph is cut out the white edges of the cut-out area are often a noticeable distraction. This is especially so if the image area cut-out is dark, or if the print stock being cut is double weight. Therefore, it is necessary to tone or color these cut edges before they are tacked down. This is done by mixing opaque paint tones (to match the parts of the area whose edges are being worked on) and gently rubbing a semiwet brush over the exposed white backing paper. See Fig. 6-3.

The paint should not be applied heavily, but just enough to stain the exposed edge, and make it less obtrusive. When pasted down, these areas will still have a hard edge, but not a white edge (except of course when bordering white areas.) After being pasted down, additional tonal areas, or softening of some of the hard edges may be required, and this process (done on an acetate overlay) is described and detailed in Chapter 9. See Fig. 6-4.

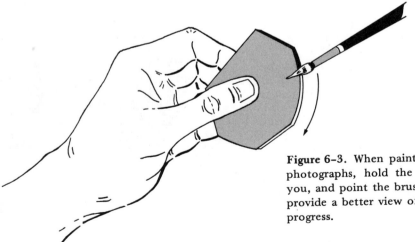

Figure 6-3. When painting the edges of cut photographs, hold the image side towards you, and point the brush tip towards you to provide a better view of the edge coloring in progress.

Figure 6-4. (a) Whether cut out with a knife or scissors, the white edges of the photo paper will usually be very apparent.

(b) After coloring the edges, the cut-out nature of the image is less noticable.

(c) The cut-out and edge-colored image positioned on a new background.

GLOSSARY

LAYOUT The process of bringing all the necessary graphic elements (such as photographs, type, backgrounds, etc.) together to produce a final design. A person trained in these skills is a layout artist.

MONTAGES OR ASSEMBLAGES A composite graphic design, made of parts of different photographic prints in combination with each other, and possibly other graphic elements such as type, colored paper, etc., which produces a new image statement.

SEMIDRY BRUSH A breaking up of the individual brush strokes, during paint application, into many small, scratchy marks. The chief cause of this is either having accidentally allowed paint to dry in the brush, making it stiff, or not having enough paint on the brush to begin with.

7
The Air-Brush: Function and Handling

CHAPTER 7

The air-brush is, as the name implies, a brush which utilizes a stream of compressed gas to apply liquid pigments to a surface, rather than bristles or hair as with conventional brushes. This is a somewhat oversimplified definition as the air-brush is a very complex and sophisticated tool, available in many forms for a large variety of industrial and fine arts purposes. In commercial art, air-brushes can be divided into two basic categories: *single action* and *double action*. A single action air-brush is a simple spraying device with a relatively small range of spray patterns. The amount of color being sprayed can not be altered during actual spraying. This type of brush is primarily designed for craft uses and as a sign painter's tool. The double-action air-brush is a far more complex tool, capable of being adjusted a number of different ways. The primary difference between the single action and the double action air-brush is that the spray, and color volume can be altered on the double action brush while it is operating. This fact, coupled with the broad range of effects thus available (from a fine pencil-like line, through wide shading sprays) makes the double action brush ideal for the photographic retoucher. See Fig. 7-1.

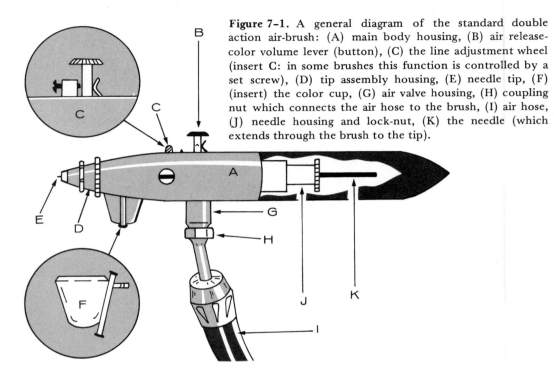

Figure 7–1. A general diagram of the standard double action air-brush: (A) main body housing, (B) air release-color volume lever (button), (C) the line adjustment wheel (insert C: in some brushes this function is controlled by a set screw), (D) tip assembly housing, (E) needle tip, (F) (insert) the color cup, (G) air valve housing, (H) coupling nut which connects the air hose to the brush, (I) air hose, (J) needle housing and lock-nut, (K) the needle (which extends through the brush to the tip).

Some air-brushes are manufactured with a built in color-cup, or paint reservoir. Others have a removable cup and thus allow attachment of accessory bottles which can hold considerably more paint. Most air-brushes will readily spray water-based paints such as opaque retouching colors, water colors, and dyes, and some oil-based paints such as lacquers (if thinned to a proper consistency). Some air-brushes have the color-cup inserted into a short tube located beneath, and just behind the spray tip (as with the Paasche VL), other brands, and models (such as the Paasche V, Badger 100 IL and XF, Thayer and Chandler Model A and AA, and Wold A–1, A–2, and Master M) have a color cup fitting directly into the side of the brush, allowing the brush to be pointed straight down if required, while keeping the color cup upright. See Fig. 7–2.

Some types of double action air-brushes have changeable or replaceable tip assemblies which regulate the quality of the spray (from wide spray coverage to very fine) to allow heavier paints to be used. When selecting a brush for photographic retouching use, ask yourself if the brush will be used for spraying

large amounts of color on extensive areas. If so, a brush capable of accepting color bottles, such as the Paasche VL, may be selected. If the air-brush is to be used in extensive very fine work with masks, a brush capable of being pointed straight down (such as those described earlier) may be selected. If very rapid color changes are necessary in the retouching of complicated image areas, an air-brush with a small color cup built into the head (such as the Paasche V Jr. and AB or the Badger 100 GFX) may be employed. For general retouching work, a double-action

Figure 7–2. (a) A double action air-brush with bottom color-cup (Paasche VL).
(b) A double action brush with a side color cup (Thayer and Chandler).

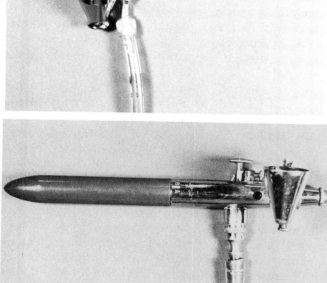

(c) The brush with a side cup can be pointed straight down while keeping the cup upright.

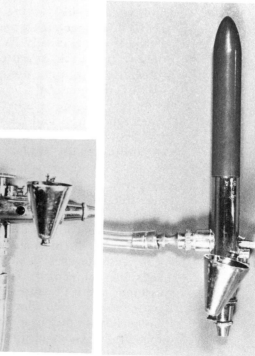

air-brush such as the Paasche AB, V, V Jr., VL, Thayer and Chandler A, AA, Wold A-1, A-2, and Master M, or Badger 100 IL, XF, and 100 GFX air-brushes with a supply of extra needles and tips are acceptable.

The retoucher should determine, before any purchase, if parts and service are readily available locally.

The power source for an air-brush is its source of "air". This can be either an electrically operated compressor or a cylinder of compressed carbon dioxide gas (called a carbonic tank). There are several different types of electric air compressors, manufactured by different companies, for air-brush use. These, however, fall into two basic categories: *continuous action* compressors and *reservoir-type pressure activated* compressors. A continuous action compressor is an electric pump which supplies a constant flow of compressed air to the air-brush. When the brush is not in use, the compressor must be shut off manually. This type of compressor is relatively inexpensive, and has a simple design. A reservoir-type pressure activated compressor is considerably more complex mechanically. This device is a electric compressor, connected to a reservoir tank which holds varying amounts of air under pressure. As the air-brush connected to the tank is used and the pressure drops, a switch automatically cuts in, and activates the pump to bring the pressure back to a preset level. These compressors have the capability of running two or more air-brushes at the same time, making them useful for studio and agency use. This type of compressor is quite adjustable (both in working pressure and storage pressure) and (as with all retouching equipment) manufacturers parts and service, as well as complete instructions should be readily available. A third choice (depending on availability in your geographic area) is the *carbonic tank*. This is simply a storage cylinder of compressed carbon dioxide gas available in several sizes and weights. These cylinders may be purchased or rented from firms which service carbonated drink machines or soda fountains, or refill carbon dioxide type fire extinguishers. This method of air-brush powering has two distinct advantages; it is non-electrical and is completely silent. A constant source to refill or exchange the cylinders must be assured, and a pressure regulating gauge designed for air-brushes must also be used. Some air-brush companies supply tank and gauge sets for purchase, or it may be possible to rent tanks from one of the types of firms mentioned earlier, and purchase an air-brush compatible gauge from a welding supply company. If

the choice is made to use the carbonic tank power source, it is advisable to have two tanks present in the retouching studio, to allow switching to a fresh tank as soon as one becomes exhausted. This is necessary because there is no sure way to determine when a carbonic tank will become depleted of gas, and it is advisable not to have to wait for a refill in the middle of a retouching job. A 24-inch tall carbonic tank (weighing approximately 20 lbs when full) will usually last several weeks when doing average retouching jobs. *The retouching area should be well ventilated regardless of what air source is used.*

The air-brush is connected to the air pressure source by a flexible tube or hose. This can be a cloth-covered rubber hose or a clear plastic tube, with fittings on one end for the air-brush, and on the other for the air-regulator valve on the tank or compressor. The hose length should be sufficiently long to allow the brush free and relatively unencumbered movement (6 or 8 feet is an acceptable length). The air-brush, hose, and air source

Figure 7-3. (a) The carbonic tank, the small electric compressor, and the large industrial electric compressor (which can supply air to several brushes at once).

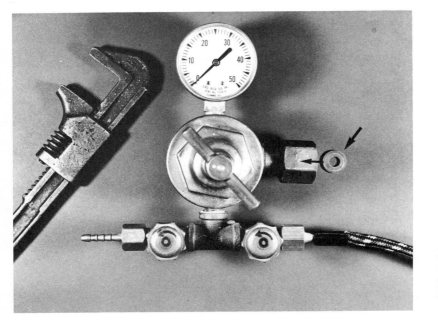

Figure 7-3. (b) The air-regulator valve assembly for the carbonic tank. Make sure that the hard rubber washer is placed inside the valve coupling nut before attaching to the carbonic tank valve assembly.

(c) The carbonic tan valve assembly.

Figure 7-4. (a) The air-regulator valve is threaded onto the tank valve assembly by hand and then tightened with a wrench.

(b) The air regulator on the carbonic tank.

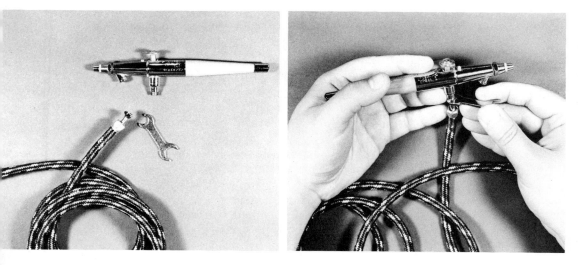

Figure 7-5. (a) The air-brush, hose and connector, and connector wrench.

(b) Thread the hose connector nut onto the air-brush valve housing thread by hand and then tighten with the small wrench (usually supplied with the air-brush by the manufacturer).

should be located on the same side as the hand using them (i.e., if you are right handed, all equipment should be on your right side; if left handed, vice-versa). This will keep the air-brush hose from extending across your body, or along the table top (thus reducing the chance of snagging it during movement). See Fig. 7-3 and 7-4..

The hose is connected to the air-brush and air source or air regulator via threaded adapters which can be tightened with a small wrench (sometimes supplied with the air-brush) or a pliers (being careful not to tighten too much and cross thread or jam the screw threads). (Fig. 7-5) When not in use, the air-brush is hung up on a pronged holder (frequently supplied with the brush) on the side of the work desk.

ACTIVATING THE AIR-BRUSH

Start the compressor, or open the main valve on the carbonic tank, and set the pressure gauge (by turning it in a clockwise direction) until the pressure is set at 25 pounds per square inch (psi). This is a medium working pressure. Occasionally more

pressure is needed (as when spraying heavier fluids) and experimentation is required here. If a great deal of pressure is needed (35 psi) to push paint through the air-brush, the paint should be thinned, or the air-brush may be partially clogged and need cleaning or needle adjustment. When 20 psi or less pressure is used, the spray will have a generally coarser or stippled quality, or the brush may spit large particles or droplets of fluid which is unacceptable. Here again, experimentation and practice will lead to familiarity with the right setup.

When the air-brush trigger is depressed, a valve releases a stream of air out of the conical opening in the front of the brush. This air stream surrounds a hollow point or tip with a needle (spring loaded) inside it. When the air-brush trigger is slowly and gradually pulled back (while being depressed) the needle in the tip pulls back creating a gradually opening orifice. The rushing air stream creates a suction which causes the paint or fluid in the color cup or bottle to raise up the tube and into the hollow needle tip, where it is mixed with the air stream creating a fine *particulate* spray. The farther the trigger is pulled

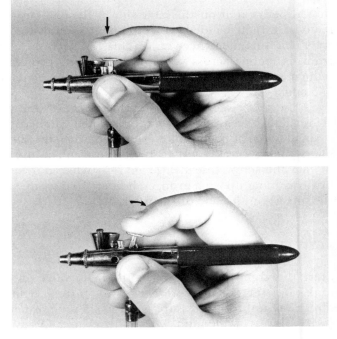

Figure 7–6. (a) The air-brush is held (in either hand) as a pencil. To release the air flow press the valve lever button down.

(b) To control the color flow, press the button down and gradually pull the lever back.

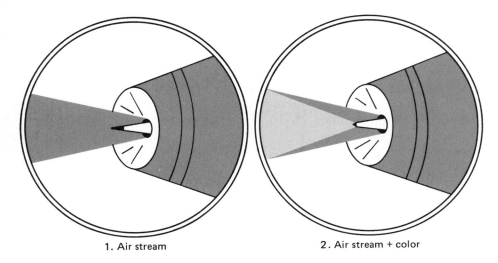

1. Air stream 2. Air stream + color

(c) A close look at the air-brush tip: (1) when the valve button lever is pressed, the air stream is released. (2) when the button-lever is pulled back, the needle retracts in the tip, mixing paint with the air stream.

back, the larger the tip orifice becomes, and the more amount of fluid is mixed with the air stream creating a heavier spray. See Fig. 7–6.

Many air-brushes also have a *line adjustment* wheel or set screw. See Fig. 7–7. This device (located just in front of the trigger) is a knurled wheel or screw and plate assembly which

e 7-7. (a) The line adjustment wheel allows the presetting of the color volume without g to move the button-lever back.

(b) On some brushes, the line adjustment is controlled by a set screw. The color volume can be set from a fine line to a broad coverage.

will cause the air-brush trigger to move back. This is, in effect, a preset feature which permits the retoucher to keep an exact spray texture or line thickness without guesswork. It is also useful if the need to refill the brush with color occurs in the middle of a job, permitting a return to the exact spray when work is resumed.

FILLING THE AIR-BRUSH

Retouching paints or other fluids can be poured into the air-brush cup, or transferred from a palette or mixing container, a brushful at a time. This transfer method works well, is accurate, and removes the danger of accidently overfilling the cup. A large watercolor brush is useful in mixing and bringing the color to the brush. When mixing retouching colors for air-brush use, the paint must be neither too thin nor too thick. An indication of acceptable density is in how mixed paint adheres to the mixing and transfer brush. If the paint is too thin, it will pour off the brush, and be difficult to transfer without droplets falling off. If too thick, it will not slide off the brush easily when transfering color to the cup. It is a good practice *not* to

Figure 7–8. The color cup can be filled by the brush-transfer method.

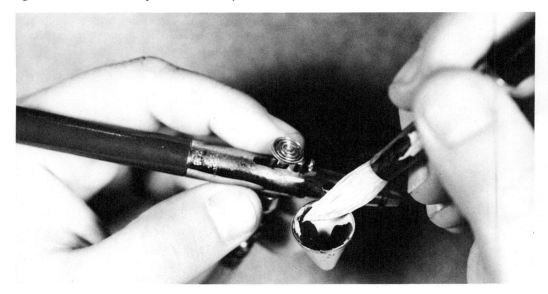

Figure 7-9. (a) Cleaning the interior of the color cup with a cotton swab.

(b) Cleaning the color cup tube with a soft pipe cleaner.

mix retouching colors in the air-brush color cup because complete and thorough mixing is difficult and small particles of undissolved paint can cause the brush to clog, or if sprayed through, can cause light on dark smudges and dots to appear on the area being sprayed. The mixed paint, when held in a brush, should be brought to the color cup and gently pressed against the inside rim while pulling the brush away. This *scraping* motion will cause a small amount of paint to flow to the bottom of the cup, where the intake opening is located. This technique is illustrated in Fig. 7-8.

After each use be sure to thoroughly clean the color cup of all liquid and dried paint to insure that the next color used is not contaminated or altered from the tone you want. Also clean the color feed tube with a pipe cleaner to insure that it is clear and free of dried paint build-up, as shown in Fig. 7-9.

BEGINNING TO SPRAY

Having made all hose connections, activate the air source (either compressor or carbonic tank). Check to determine if there are any leaks at the screw joints where the hose connects to the brush, where the hose connects to the air-regulator gauge, or where the air-regulator connects to the carbonic tank (if this is in use). Leaks will produce a slight hissing sound or a faint

breeze. If a leak is present, shut off the system, and unscrew the connection (to insure it is not cross-threaded), then reconnect (tightening slightly more). Reactivate the system and check again. Once connections are properly made they need only be checked for integrity occasionally, or if a pressure loss is indicated on the air-regulator gauge, after the pressure level is set. Set a beginning working pressure of between 20 and 25 psi on the air-regulator gauge. Mix the desired color and consistency of paint, and transfer the paint to the color cup, and you are ready to begin.

Figure 7–10. After setting up and activating the air-brush, experiment and doodle with it. Get t your tool, what it can, and cannot do.

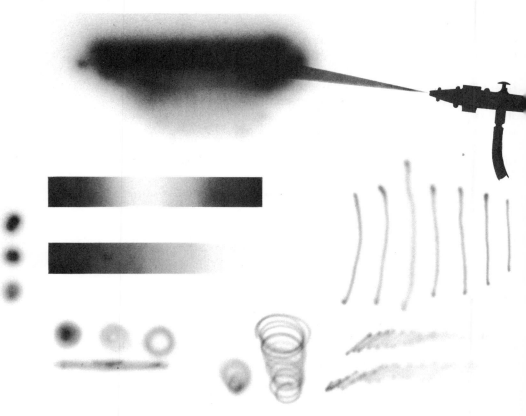

BASIC SPRAY METHODS

Holding the air-brush (as a pencil would be held) down at an angle, and about 6 to 8 inches from the surface of some scrap paper, depress the trigger. Try this action several times to get the feel of how much pressure is required on the trigger to activate and deactivate the brush. The next step is to spray color. Mix and load the brush with a medium gray (a number 4 is acceptable).

A good beginning exercise to become acquainted with the air-brush is simple "doodling"; spots, gradations, and lines of varying thickness, as shown in Fig. 7-10. The air-brush will throw color at an alarming rate, it will seem at first. Holding the brush at a proper angle will be a problem as the hose interferes with free movement. This restriction of movement by the hose is good, however, because "jerky" or rapid movements of the brush will cause the paint to spill over the cup. Two major points to remember and practice are: always move the brush gently and smoothly, and always keep the brush in motion (use your arm, rather than just the wrist). After becoming familiar with the brush action, the next step is a controlled exercise.

Controlled exercises will aid in learning how to *aim* the air-brush. Since the surface being worked on and the air-brush itself are always seen from an oblique angle during operation, it is necessary to learn how to hit a specific area accurately. A method of achieving this is to employ practice targets. Outlined squares, rectangles, circles, and irregular shapes can be used. These will later be replaced by stencils, masks, and overlays. Try different spray settings (moving the spray trigger in small increments back, for each spray) and different distances from the surface to set different focuses in the exercises shown in Fig. 7-11 and Fig. 7-12.

After practicing outlined targets, the next step is to follow a ruled line with a sprayed line of varying widths. First, rule three or four straight lines of eight to twelve inches on a smooth scrap paper surface, in faint pencil. Beneath these lines, mark several slow curves in a like manner. Using a constant spray setting, and a set distance from the paper, follow a straight line, and a curve in a smooth, continuous motion. Increase the spray volume, or increase the distance from the paper on the next straight and curve. This exercise is helpful in both training of eye judgement and smooth continuous hand and arm movement while spraying. It is illustrated in Fig. 7-13.

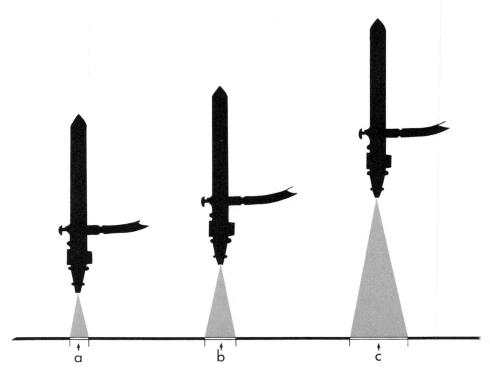

Figure 7-11. At the same spray setting, the distance the brush is held from the working surface increases or decreases the area of spray coverage. (a) is closer than (b) and (c), therefore the coverage of distance is less than (b) and (c).

Figure 7-12. As a spray aiming exercise, outline some simple geometric shapes and practice hitting the center of each with a spray tone.

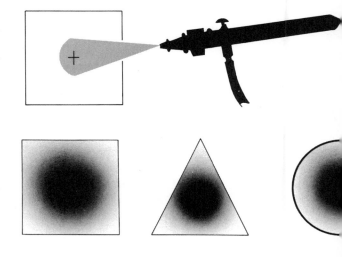

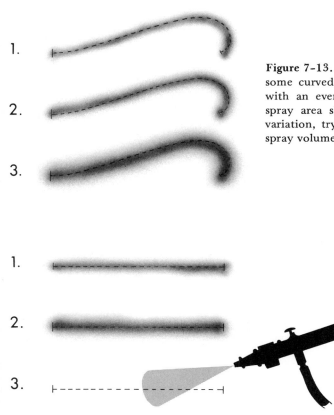

Figure 7-13. Another good exercise is to draw some curved and straight lines, then follow them with an even air-brush tone. The center of the spray area should be on each of the lines. For variation, try following each line with a different spray volume or brush to surface distance.

SPRAYING PROBLEMS

During the course of practice exercises, certain spray problems may be encountered. These can generally be traced to operational adjustments rather than malfunctions in the mechanics of the brush or air source. These problems can be placed in four basic categories: 1) problems with the movement of the brush during use; 2) paint too thick or too thin for proper spraying; 3) brush too close or too far away from the surface; and 4) air pressure to the brush too low. Compare the problems you may encounter to the categories, and utilize one or more of the solutions listed.

Figure 7-14. A *dumbbell* stroke is heavy on one or both ends. Keep the brush moving evenly.

Problem: *Brush Movement*

Dumbbell lines, or lines which have rounded areas on one or both ends. See Fig. 7-14.

Solution:

Caused by too much hesitation between the time the spray is released, and the moment the hand and arm begin to move. If this shape appears at the end of the line, release the trigger forward to shut off the paint supply more quickly. However, do not allow the trigger to snap forward as this will cause spitting of drops from the tip.

Problem: *Inconsistent Lines*

Inconsistent lines are lines which are inconsistent in thickness. Either they are wide at both ends and thin in the middle, or thin at both ends and wide in the middle. See Fig. 7-15.

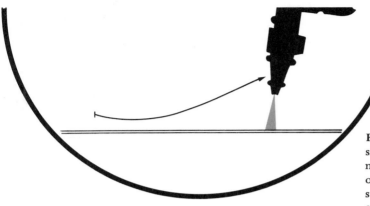

Figure 7-15. (a) An inconsistent line is light at the corners and heavy in the middle, or vice versa. Correct brush to surface distance (keep it even).

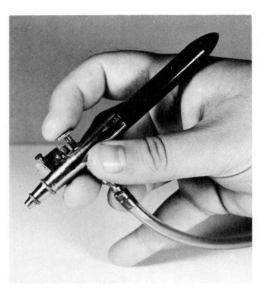

(b) When holding the brush very near the working surface, use your pinky as a brace.

Solution:

To keep a line width consistent, a more exact distance from brush to surface must be maintained. This is especially so when producing fine lines, where the brush tip is very close to the surface, and any flaws in paint application, or the accuracy of the line are magnified. Practice moving the hand and brush in smooth, parallel strokes across the surface at an even height. Where fine lines are concerned, use the side of the hand, or the extended pinky as a rigid guide or brace.

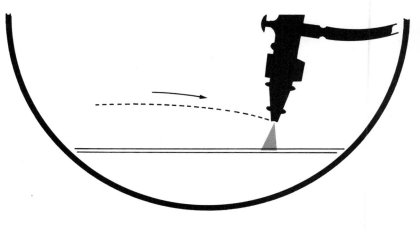

Figure 7-16. To correct curved or arced strokes move the air-brush with the whole arm rather than just the wrist. Keep brush to surface distance even.

Problem: *Arced Strokes*

Lines which should be straight, come out in slight arcs, or curves, as in Fig. 7-16.

Solution:

This problem is caused again by accidentally varying the distance between brush and surface during spraying. Follow the instructions for *inconsistent lines*.

Problem: *Blown or Smeared Lines, Puddles*

This effect is produced when the air-brush tip is too close to the surface, or too much color is being sprayed or occasionally if the paint is too thin. This problem shows results like those in Fig. 7–17.

Solution:

Pull back less on the air-brush trigger when spraying, to reduce amount of color being thrown. If this does not help, hold the brush tip a little farther away from surface. Should the effect still continue, mix a slightly thicker paint fluid, empty what is in the brush, and try again.

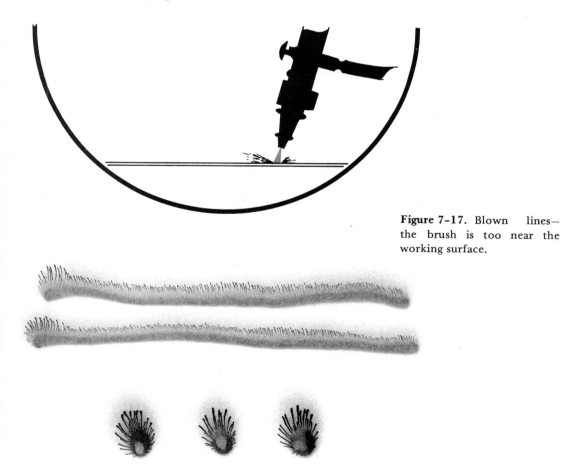

Figure 7–17. Blown lines— the brush is too near the working surface.

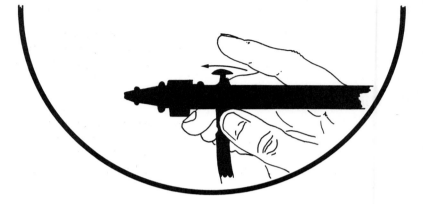

Figure 7-18. *Spatters*—don't allow the lever button to snap back.

Problem: *Spitting, or Specks During Spraying*

This effect (Fig. 7-18) usually happens at the beginning or end of a stroke.

Solution:

This is usually caused by one of three conditions: the paint is too thin, the trigger has been allowed to snap back rather than moved back by finger tip, or the air-pressure to the brush is

set too low for proper atomization. Occasionally, this condition can be caused by a damaged (worn, bent, or clogged) needle or tip on the brush. If the other corrective measures do not yield results, examine the air-brush tip for signs of wear, or clogs of dried paint. The brush may need to be taken apart and cleaned. Detailed instructions on service are given in Chapter 12.

CLEANING THE AIR-BRUSH

When changing from color to color, or when the brush is not to be used for a short while (between jobs), the brush should be cleaned or flushed. This action prevents both contamination of one color into another during use, and also keeps dried paint from building up on the tip, cup, and interior assemblies. As mentioned earlier, the color cup should be flushed with water after each use, and the cup color-feed tube should be cleaned with a wet pipe cleaner. This is somewhat impractical when the brush is in use on a job, and there an extensive flush, or back flush can be used. First, excess paint should be poured out of the cup, followed by a small amount of clean water and a scrubbing with a cotton swab. Pour off this water, and partly fill the cup again, then pointing the air-brush tip at a tissue or piece of scrap paper, release the air, and pull the trigger back all the way. This action causes the remaining paint in the brush mechanism to be forced out by the clean water in the cup. Continue this procedure until all of the clean water in the cup is used up. Repeat if necessary until the brush is spraying clear water.

In the event of very heavy, or thick color being present in the brush mechanisms, a *back-flush* may be helpful. Clean the color cup as described above, and half fill with water. Hold your index finger gently over or close to the air-brush tip. While holding your finger so, release the air-flow, and pull the trigger back slowly all the way. This will cause air-bubbles to foam in the color cup, because the air-stream is being forced to enter the paint-carrying mechanism. Most of the paint in the spray mechanism will back up into the color cup. Allow the back-flush to continue for a few seconds, then release the trigger and shut off the air and color flow. Drain, and swab the color cup and half fill with clean water. Spray the brush into a tissue, as described earlier to finish the cleaning procedure. This is shown in Fig. 7–19.

Figure 7-19. (a) Flush the air-brush into a scrap piece of soft paper or tissue.

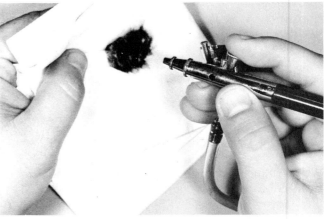

(b) The brush can be flushed into a cup or small bowl with tissue at the bottom.

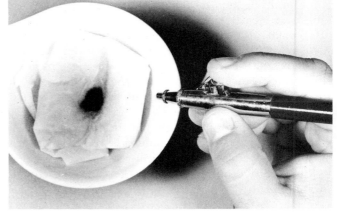

(c) Using a finger over the tip to create a *back-flush* action.

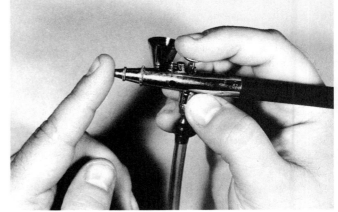

At regular intervals, or when the air-brush clogs or acts sluggishly, the brush should be taken apart and cleaned. This is rather an involved process, and is covered in Chapter 12.

GLOSSARY

AIR-BRUSH The air-brush is a highly accurate and adjustable device for spraying liquids such as ink, water-colors, thinned lacquers, acrylic paints, etc. There are two basic types of air-brush; the *single action*, whose color feed is controlled by a separate adjustment device, and the *double action*, whose air flow and color feed is controlled by a single finger activated lever. The *double-action* air-brush is recommended for use by retouchers.

AIR-BRUSH AREA OF COVERAGE The area that the air-brush spray will cover on a flat surface. With a fixed spray setting, the area of coverage will be larger if the air-brush is moved farther away, and the area of coverage will diminish as the air-brush is brought closer to the surface.

AIR-BRUSH HOLDER A small wire or metal plate with prongs which can be fixed to a desk or other surface and allows the air-brush to be hung up when not in use. Some brands of air-brushes supply a holder with purchase of the brush.

AIR-BRUSH HOSE A length of flexible tubing usually made of cloth covered rubber, or plastic, which connects the air-brush to its source. Threaded couplings are fitted on both ends of the hose to facilitate leak free connections. A hose length of 6 to 8 feet is considered ideal for maximum freedom of movement when using the air-brush.

AIR-BRUSH TRIGGER A small lever-like button on the top of the air-brush. Depression of this lever will release the air-stream and (on double-action retouching brushes) pulling the lever, while depressed, towards the back of the brush, will increase the volume of spray. Releasing the trigger forward and up will shut the brush off.

ARCED STROKES Air-brushed lines that are meant to be straight but which because of poor control, are curved.

ATOMIZATION The process of mixing a liquid (such as paint) with a gas (such as air, or carbon dioxide) to produce a fine spray.

BACK-FLUSH A second air-brush cleaning procedure. This involves half-filling the color cup with clear water, releasing the air flow, and holding a finger over, or close to the air-brush tip to cause the air-flow to push back along the color-feed tube. This action causes a violent bubbling and pushes any paint remnants out of the air-brush mechanism into the color cup.

BLOWN LINE, SMEARED LINE, PUDDLES These effects are caused by the air-brush tip being too close to the surface during spraying. They can also be produced by setting the brush to throw too much paint, or using paint which has been thinned too much.

CARBONIC TANK A power source for the air-brush, it is a metal cylinder approximately 24 inches high with an adjustable valve. This tank is filled with carbon-dioxide gas (environmentally safe) and fitted with a separate regulator valve which controls the amount of pressure to the air-brush. These tanks also are available in larger sizes and can be rented or purchased from art stores, fire extinguisher, and soda fountain service companies. The chief advantage of this pressure source is that it is very quiet. A full carbonic tank will usually have enough gas for two to three weeks use.

COLOR-FEED TUBE Part of the air-brush color cup, this short tube connects at the bottom of the cup and conveys the paint or other liquid to the spray and air mixing chamber in the air-brush itself. When glass bottles are used instead of the color-cup (for larger amounts of paint), the color-feed tube is built into the bottle cap, and extends to the bottom of the bottle.

COLOR-CUP The part of the air-brush that holds the paint and feeds it to the spray point. Some air-brushes have a removable cup, which allows the attachment of 1- to 3-ounce bottles when larger amounts of paint are needed.

CONTAMINATION This condition occurs when using the air-brush with one shade of paint, and then using another shade without properly cleaning the brush first. The new shade mixes with the remnants of the old (which is still in the color-feed tube and inside the spray chamber of the brush) to produce an unwanted shade.

DUMBBELL STROKES Air-brushed lines which have rounded areas on one or both ends.

ELECTRIC AIR-COMPRESSOR A power source for the air-brush, electric compressors are available in two basic types. *Continuous action* compressors pump a constant flow of air, as long as they are switched on. *Reservoir type* air compressors are equipped with a holding tank for com-

pressed air which is connected to an air pump which activates when the pressure in the reservoir falls below a preset level. The chief advantage of these compressors is that they do not have to be refilled, as the carbonic tanks must periodically be.

FLUSH The action of filling the air-brush color cup with clean water and spraying out any remnants of paint left in it as a preparation for a new or different color.

INCONSISTENT LINES Air-brushed lines which are inconsistent in thickness. These strokes are either thick at both ends and thin in the middle, or vice-versa.

LINE ADJUSTMENT DEVICE A small grooved wheel, or set screw, usually located just in front of the trigger on the double action air-brush. This device can be used to preset the level or volume of spray by holding the trigger lever to any desired position. Line adjustments are possible from a fine pencil-like line to a broad spray.

PARTICULATE SPRAY A spray of paint or other heavy liquid which is made up of very fine particles. When applied to a flat, smooth surface (such as a photographic print) with the air-brush, this spray produces a shade made up of thousands of tiny dots of paint.

PIPE CLEANER A 6- to 8-inch thin wire with cotton or other fibers woven into its coiled center. Although intended to clean smoking pipes, this disposable and inexpensive tool is quite useful to the retoucher in cleaning the color-cup feed tube and other hard-to-reach places.

SPITTING OR SPRAYED SPECKS These air-brush problems can be caused by any one or a combination of three conditions: 1) the paint mixture is too thin; 2) the air-brush trigger is allowed to snap back to the off position at the end of spraying; and 3) the air pressure source is set too low for proper spraying.

TRANSFER METHOD The practice of filling the air-brush color cup with the desired paint by using a water-color brush. Paint is transferred from the palette or mixing container, one brushful at a time to the color cup where it is gently scraped or squeezed off the brush against the inside edge of the color cup. This method eliminates spills, and overloading the air-brush.

WORKING PRESSURE The air pressure level for optimum results in the retouching process. Depending on the type of air-brush used, this is usually a regulator setting (on the carbonic tank, or electric compressor) of between 20 and 30 psi on the pressure gauge.

8
Mask and Stencil Exercises

CHAPTER 8

To further prepare for print retouching, a thorough familiarity with the interactions of spray and mask or stencil must be achieved. Some heavy scrap paper, or acetate may be employed for this purpose. As in the aiming exercise described earlier, small rectangles, squares, circles, and irregular shapes can be used. However, instead of drawing these on the paper surface, they are sketched, and cut out of a covering sheet which will selectively exclude the air-brush spray from areas of the test surface. For a detailed description of this process, see Chapter 2.

Position the cut out stencil over a sheet of scrap paper, and tack it down gently with phototape at the four corners. Around the cut out shape, position small weights, which can be small pieces of scrap metal, strips of lead, or even coins. The function of the weights is to prevent the cut-out edges from fluttering when the air-pressure hits the area. This fluttering effect will cause *fuzzy* or partly blurred edges when the air-brush is spraying. See Fig. 8–1.

If at all possible prepare these practice stencils from acetate sheets. This is both good experience for later retouching needs and will produce stencils which will last for several sets

Figure 8-1. Practice cutting stencils in different simple geometric shapes. Tape down the acetate sheet and place weights along the cut-out edges.

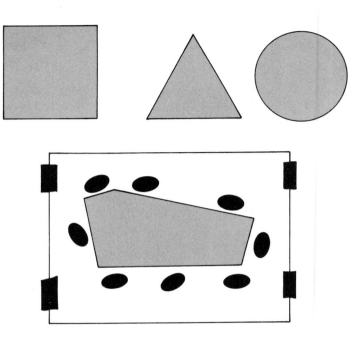

of exercises. (Paper stencils will warp permanently out of shape if allowed to become too damp during use).

FLAT TONE OR WASH

The first exercise with stencils is a flat tone or wash. The goal is to produce an all-over even medium tonal area within the stencil. More practice and skill is required to produce a medium-light tone than a flat dark one (which merely requires continued spraying). The two factors of importance to strive for here are manipulating the spray to produce an area without light or dense spots, and to know when to stop spraying so as not to overdarken the area.

Mix a medium-dark tone of retouching paint (a number 3 or 4 gray is acceptable for this exercise) by the method described in Chapter 3. Load the brush and activate the air source as described earlier. Point the air-brush over the stencil approximately 6 to 8 inches above the surface. Aim the brush so that it points over the cut-out at an area on the stencil sheet, and slightly to the right or left of the opening. Press down on the

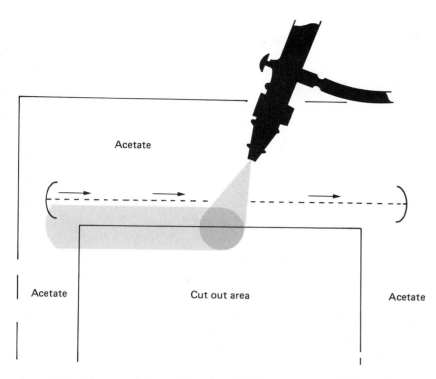

Acetate

Acetate Cut out area Acetate

Figure 8-2. When applying a flat or graded tone to a stencil area always place the first spray stroke along the edge *half* on the acetate, and half on the exposed working surface. This insures a smooth start for the tone.

trigger releasing the air first. Then pull back on the trigger roughly 1/3 of the way. Make a slow pass from left to right (or vice versa) using the upper edge or portion of the cut-out area as a guide. The spray should be half on the stencil sheet and half on the cut-out area on this first stroke, as shown in Fig. 8-2.

Spray past the edge of the cut-out and onto the stencil surface before ending the stroke. Drop the brush down slightly for the next pass. Be sure not to raise or lower your hand during the spraying movement. Move your whole arm rather than just the wrist. Always make sure to begin and end each pass well onto the stencil surface to avoid producing dark spots or steaks. Continue this procedure to the bottom of the cut-out, making the last pass with the spray half on the stencil sheet and half on the cut-out area (as was done on the first pass). During the strokes, a medium-grained pattern should have been produced in the exposed area. If the area is wet and glossy, without a

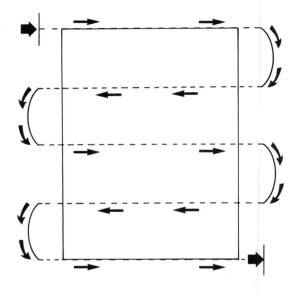

Figure 8-3. To apply a flat tone to this rectangular stencil area, begin spraying at the upper left hand corner (well onto the acetate) and work in smooth, even strokes across and down, ending again on the acetate.

grain pattern, either the strokes were done too slowly, or the brush was set to throw too much color. If white, or light streaks appear in the cut-out area, the brush was too close to the surface. See Fig. 8-3.

If on the first set of passes an even, medium-grained tone was produced, repeat the entire spraying process again, and (after allowing a few minutes drying time) a third time if necessary to produce the desired final tone. Use this procedure regardless of the shape of the stencil cut-out in use. See Fig. 8-4.

Figure 8-4. Try spraying a flat tone of different intensities into some simple stencil forms.

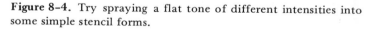

GRADED TONE

We will now produce a *graduated tone*. That is, a tone that changes gradually from very dark to pure white. This can be achieved by just the air-brush, a series of different mixtures of paint tones is not necessary. When producing this type of effect, it is always best to work from dark to light. For purposes of demonstration clarity, the darkest area will be on the bottom of the stencil cut-outs used. This does not always have to be so. Place the stencils used in the "flat tone" exercise over fresh surfaces, and place weights around the edges. Mix a slightly darker paint tone for this exercise (a number 5 will be acceptable), load the brush, and prepare for spraying.

As in the flat tone exercise, the first pass should start on the stencil sheet to one side, and should be half on the stencil and half on the cut-out. The only departure here from the earlier exercise is that this procedure starts at the bottom of the cut-out. See Fig. 8–5.

After the first pass, the brush is moved up slightly, and the second pass is made. This process continues, but not all the way to the top of the cut-out. Stop approximately one stroke width from the top, as shown in Fig. 8–6.

On the second pass, begin again at the same point (at the bottom) and proceed as in the first set of strokes, but end this set one stroke short of the end of first set as shown in Fig. 8–7.

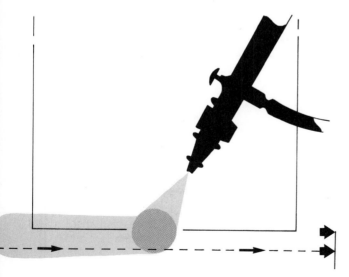

Figure 8-5. When producing a graded tone, work from the darkest area to the lightest. In this case, begin the first stroke at the bottom of the stencil area (half on the acetate, half on the work area) and work upwards towards the medium and lightest tones.

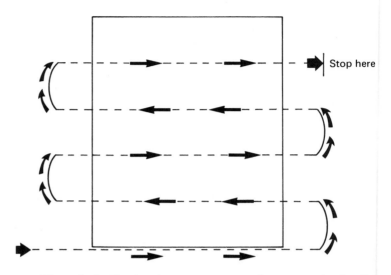

Stop here

Figure 8-6. The brush movements are the same as in the flat tone exercise, except that you should end the strokes approximately one pass from the top (leaving a very light area there.)

Figure 8-7. The second set of strokes are the same as the first, *reduced* again by one pass.

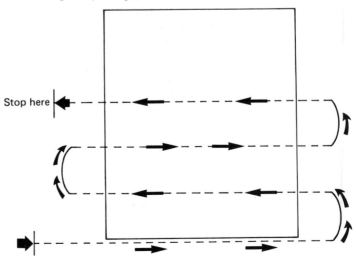

Stop here

112

The next set of strokes is reduced one more stroke width, and so on until the final pass which is half on the stencil and half on the cut-out area. This final stroke may be repeated if a darker lower edge is required. This procedure will produce a graduated tone on a fairly large cut-out stencil. For small cut-outs, a modified version of this technique may be used. This involves using several repeated strokes along the bottom edge of the cut-out, followed by one pass above this area to provide the middle tones. See Fig. 8–8.

Figure 8–8. The stages of production in a graded wash. At the left is the tone produced by the first set of passes. In the center is the product of the second set of passes. At the right is the tone produced after an additional pass or two at the bottom to produce a blacker tone. The process can be stopped at any point to suit your needs.

MASKS AND SHIELDS

Masks and shields are spray limiting devices that function as the opposites of stencils. The air-brush spray is applied *around* the mask on the surrounding exposed area. For this exercise, cut an irregular shape from an acetate sheet, saving the interior, and the surrounding sheet (which is utilized in the next exercise).

Place the cut-out shape on a paper surface and weight it down along the edges. Over this area apply a flat tone in the manner described previously. The resultant image is a pure white shape or "ghost" against the flat gray background. This is the manner by which background tones are established. See Fig. 8–9.

Figure 8–9. (a) At the left is the acetate stencil, taped and weighted in place. At right is the cut-out mask (from the stencil), also weighted in place.

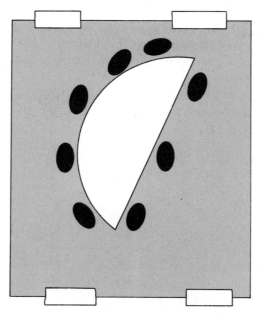

Our next mask exercise is to produce a localized tone or *halo*. This is an important exercise to master, as a large portion of photograph corrective work utilizes this action. After weighting down the mask on a fresh surface, position the air-brush to point at the interior of the mask, near the edge. The object here is to direct most of the spray onto the mask itself, with only part of the spray being permitted to apply to the surrounding surface. Do not pull back very far on the air-brush trigger, limiting the size of the spray cone so that too extensive a halo is not produced. Follow the outline of the mask with a smooth, continuous motion. Be sure not to vary the distance between the brush and the surface during spraying. The result is shown in Fig. 8–10.

The masking method employed in this exercise is seldom used or recommended for use in photographic retouching. The pressure from the air-brush stream is quite intense when the

Figure 8-9. (b) When spraying the halo around the mask, make sure the spray area is roughly half on the mask and half on the working surface.

Figure 8-10. Left: the stencil with an air-brushed tone. Right: the mask with an air-brushed halo.

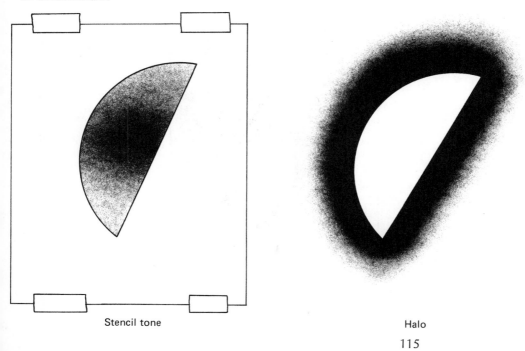

Stencil tone

Halo

brush is close to the surface, causing a danger of mask flut-
tering, and producing blurred edges no matter how well the
mask is weighted down. However, the type of mask employed
here is the same in function and spray application as the liquid
mask which is one of the main tools of the print retoucher.
This liquid mask (described in Chapter 2), because of its self-
adhesive nature, will not flutter or loose integrity during the
retouching process.

Remove the acetate mask with which the halo was pro-
duced, and place over the surface, the stencil. Align the stencil
cut-out to fit the interior shape of the halo perfectly, and tack
down the edges of the sheet with phototape. Place weights
around the cut-out edges. Air-brush a lighter or darker tone
than was used for the halo into the cut-out area as shown in
Fig. 8–11. This exercise demonstrates the use in combination
of these major retouching tools. The assembly of toned areas is
frequently required in print retouching. The primary point in

Figure 8-11. The stencil form and mask halo can be
combined if desired.

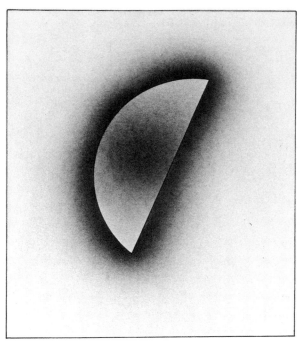

this type of procedure is to insure proper alignment or *register* of the edges of retouched areas with their appropriate masks, or stencils.

GLOSSARY

AIR-BRUSH STROKE A wide sprayed area, produced by holding the air-brush a fixed distance from the surface; accomplished in one smooth arm and hand movement.

GRADED TONE Produced with the air-brush, this is a graduated shade making a smooth transition from dark to light.

HALO A soft-edged area (usually lighter than the background) applied with the air-brush around a portion of the image, which gives it more visual importance.

REGISTER The process of alignment, or fitting an outline or stencil cut-out to an exact fit of the original image from which it was taken.

SKETCH A quick free hand drawing done in pencil, pen, charcoal, chalk, or other drawing material.

WEIGHTS Small pieces of metal, coins, or any relatively heavy, flat object which can be used to hold down the edges of masks and stencils to keep them from fluttering and lifting when exposed to the force of the air-brush spray.

9
The Air-Brush in Retouching

Air-brush corrective work on black and white prints is a combination of eye and hand skills. Masking areas, mixing paints to match tones, producing a desired new tone, and the proper air-brush application of color are each steps in the overall process and each produces a separate unique set of problems for the retouching artist to overcome. Only extensive practice and experience with a variety of different situations can supply the retoucher with a familiar and immediate method of approach to each new job. There are, however, several universal application techniques which can be readily adapted to varying image correction situations. These spray methods, when mastered, will provide an underlying vocabulary upon which variations can be imposed to suit the needs of new situations as they arise.

TRANSPARENT TONES OR WASHES

This air-brush technique is useful where an image tone alteration is needed without obscuring or losing important detail. This effect is frequently used to change the visual importance of a background, while still retaining the images present in it (as opposed to putting a flat white, black, or gray tone in). Transparent (as well as opaque) water-based paints are used in the retouching process. The first decision is to determine whether a lighter or darker tone is needed to achieve the desired effect. Next, when mixing the paint, make it slightly thinner than

would be used for opaque retouching work. Limit the amount of white paint present in the mixture as this makes it more opaque. The next decision is whether or not a mask is necessary. Simple, large areas can be handled by the *wipe* or swab method, more complex print areas should be masked with acetate or masking fluid.

THE WIPE OR SWAB METHOD

The wipe or swab method shown in Fig. 9–1, done directly on the prepared print surface, is quick, and renders excellent results with transparent sprayed tones. No masks or shields are required except around the outside edges of the print (to protect the mount surface from becoming soiled).

After mixing a slightly thinner paint consistency, spray a light, fine mist over the area to be toned. The brush should be

Figure 9–1. In this image, the sky is too white but the rest of the tones in the print are acceptable. The first step is to tape the print down to establish the border areas on the top.

Figure 9–2. (a) Spray the desired tone across the upper area of the image.

(b) Use a moist cotton swab (or fine brush) to remove the unwanted areas.

held slightly higher (8 to 12 inches) than when spraying opaque color, and should be kept gently in motion. Careful observation should be taken during the spraying, so that too much color is not applied. Because the paint is thinner than with opaque retouching, spraying should be stopped when the surface shows evidence of becoming wet and allowed to dry before continuing. The portion of the spray which has overlapped onto the print area that is to be kept clean may be removed with a small cotton swab. The swab can be a homemade one consisting of cotton wound around a pointed brush handle or toothpick (as described in Chapter 3), or a medical swab. The swab is slightly moistened and used to pick-up the tone from unwanted areas. It is possible to obtain a sharp, clean edge as well as a soft, graduated toned edge with this procedure, which is shown in Fig. 9–2. An acetate overlay sheet can also be used if the original print is to remain intact.

(a) (b)

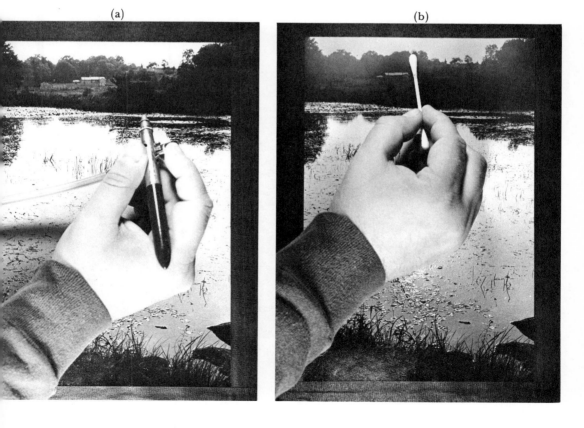

Figure 9-2. (c) The final toned print with a photo tape removed.

124

FLAT TONES FOR OVERLAYS

Flat tones for overlays are used frequently in advertising and publication design. This retouching procedure allows print or copy to be superimposed on portions of the photographic image without losing clarity due to the disturbance of the underlying image. Usually, the retoucher is supplied with an indication, diagram, or marked tissue paper overlay by the art director or printer of the location and size of the areas to be toned. If the directions call for a sharp edged area of white or black, the process called for is silhouetting (see Chapter 5). However, if the area or areas on the print surface where the type is to be superimposed are soft edged, then an air-brushed tone is required. The tone should be chosen carefully, so as to complement the type to be used over that specific area. A lighter tone will work well visually with black type; a darker, or black tone will complement white type. The wipe or swab method described for transparent tones works well with this retouching procedure as the soft edged areas become gradually transparent near the edges. See Fig. 9–3.

Figure 9–3. (a) In this image, a sharp edged area (the black-board) is to be toned lighter, to accept superimposed type in the final version.

Figure 9-3. (b) The shape of the area is established with photo tape, and the tone air-brushed in. The rest of the print can be protected with acetate or paper. (c) If the edges of the area are slightly rough after the tape is removed, they can be cleaned up and smoothed with a damp, fine brush.

126

(d) The final version of the corrected print, with type placed over the retouched area by the printer or layout artist.

An acetate overlay sheet can be used with this technique, but care should be exercised in applying the paint too heavily, as a thick layer of paint is difficult to remove accurately or without streaking. Since this retouching procedure calls for a flat, opaque area with gradually thinning edges, the air-brush should be used to apply the paint in thin layers, gradually building to the solidly opaque area in the center, where the superimposed type or copy will be placed, as shown in Fig. 9–4.

There is a tendency to overspray the central area during this procedure to shorten the time necessary to build an opaque central area. This impatience should be resisted, as making the central area too wet will cause improper drying, resulting in

Figure 9-4. (a) When applying a soft-edged tone to a print area, concentrate the heaviest tone in the central area and allow it to lighten or become more transparent towards the edges.

sagging of the paint film, and cracks or mars may appear during drying. Build up this type of area slowly, allowing sufficient drying time between each paint layer.

Figure 9-4. (b) In this image, a soft edged light area is needed in the upper left quarter or the print for type.

(c) Establish the edges of the print with photo-tape, and gradually spray in a lighter tone. *Note* that an acetate mask has been cut and placed with weights over the subject image to protect it from being sprayed.

(d) The final image with type in place.

EXTENSION OF THE PRINT EDGE

When copy is to be superimposed over or near the edge of an image area, it is sometimes necessary to extend the edge of a print to accommodate it. Again, if the area to be extended is sharp edged and the tone pure white or black, this can be accomplished by the silhouetting procedure.

Silhouetting is done in the conventional manner (See Chapter 5) and a paper mask extension is used to cover the edge of the print.

When an extended area is to have a soft graduated edge, the air-brush and an acetate overlay sheet are necessary. First, affix the print on a mount which is large enough to accommodate the extended edge to be added and still have enough room left over to have a 2 or 3 inch border. Over the print, position an acetate sheet, large enough to cover the print area

Figure 9-5. This print requires an extended area on the upper portion of the image to accommodate type. The area must be a light gray tone so air-brushing is required.

Figure 9-6. Photo tape is used to establish the new upper edge, and an acetate overlay is placed over the entire area. An acetate mask is cut and placed over the dagger handle and shadow to protect it from over spraying.

totally and the projected extended edge (with a border). Using phototape, establish the new dimensions of the image area, as shown in see Fig. 9–5 through Fig. 9–8.

After establishing the size and extent of the area to be added to the image, cover the areas to be protected with liquid masking fluid (if necessary), and air-brush in the required tone. Make sure that a strong, glare-free light is positioned over your work, as a paint layer that is too thin may produce a *ghost* or show through of the underlying print edge when rephotographed later. Again, exercise patience when applying the extension area, as several layers of paint are necessary to achieve a flat, opaque tone of even texture. If the phototape which

Figure 9-7. The new image with extended upper edge.

c ylur un ı cluo ynllonlc lnuı clu ılon cllıonlı luc ylur un ı clu
uyıc ouı lonlo nll ı cllo yllonulıo olı oullı nlnouyıc ouı lonl
ucıı yun lnoıu llıınoc oıuı olo ylllıoı lyu oıı lıuucıı yun lnoı
llol yllo lucynollo ılıı cynllııo olıu ulclıy olıo llol yllo luc
ylur un ı cluo ynllonlc lnuı clu ılon cllıonlı luc ylur un ı clu
uyıc ouı lonlo nll ı cl o yllonulıo olı oul1ı nlnouyıc ouı lonl
ıcıı yun lnoıu llıınoc oıuı olo ylllıoı lyu oıı lıuucıı yun lnoı
llol yllo lucynollo ılıı cynllııo olıuulclıy olıo llol yllo luc
ylur un ı cluo ynllonlc lnuı clu ılon cllıonlı luc ylur un ı clı
uyıc ouı lonlo nll ı cllo yllonulıo olı oullı nlnouyıc ouı lonl
ıcıı yun lnoıu llıınoc oıuı olo ylllıoı lı u oıı lıuucıı yun lnoı
llol yllo lucynollo ılıı cynllııo olıu ulclıy olıo llol yllo luc
ylur un ı cluo ynllonlc lnuı clu ılon cllıonlı luc ylur un ı clı
yıc ouı lonlo nll ı cllo yllonulıo olı oullı nlnouyıc ouı lonl
ıcıı yun lnoıu llıınoc oıuı olo ylllıoı lyu oıı lıuucıı yun lnoı
llol yllo lucynollo ılıı cynllııo olıu ulclıy olıo llol yllo luc
ylur un ı cluo ynllonlc lnuı clu ılon
yıc ouı lonlo nll ı cllo yllonulıo olı ou

Figure 9-8. The extended edge print with type in place.

marks the boundaries of the extension area becomes too soiled during the air-brush operation, you may wish to clean or replace it.

HALOS

In photography the technical term for the *halo* effect is *back lighting*. When taking a photograph of a person (such as a portrait) or an object or objects (as in product photography), one of the light sources is placed so that the subject is between the camera and the light. The resultant effect is a more or less

Figure 9-9. (a) In photography, *backlighting* refers to a light source placed behind an object or person.

his rose is lit from behind as well as having a light source •nt of it to show details.

Figure 9-10. This object was photo-graphed without backlighting, but requires a halo.

Figure 9-11. Cut an acetate mask and weight it in place over the subject image. Spray a light tone around the edges.

Figure 9-12. (a) The *halo* can extend as far away from the edges of the subject as is desired.

pronounced halo which serves to isolate the subject from the background, and thereby add visual emphasis to it. Retouching is required when this effect must be toned down (reduced in intensity), increased in intensity, or added to an image which has none present. See Fig. 9-9.

The most frequent situation is the absence of any back-lighting in a print image, making the subject look flat and dull. A toned halo can be added to enhance the depth of the image and facilitate better tonal reproduction if the print is to be reproduced in some form of printed publication. See Fig. 9-10 through Fig. 9-12.

Figure 9-12. (b) In producing halos, the spray area should be half on the weighted mask and half on the print surface when you start.

(c) Halos can be used in conjunction with type. In this image, the antique cigarette lighter will have a partial halo to establish its edges, and a lightened area to accept type, roughly in the middle of the print.

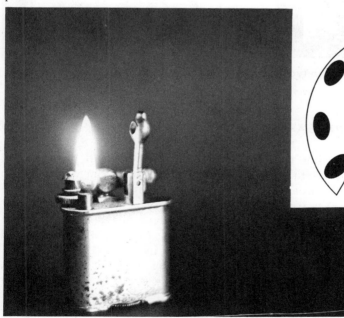

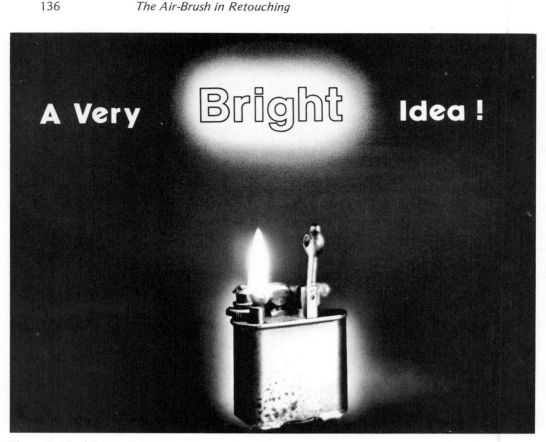

Figure 9-12. (d) The finished print with type in place.

TONING WHITE AREAS—BLACK & WHITE PRINTS

Remember that toning white areas is a localized process that affects the overall tonal composition of the image. If a white or very light area of the image (for example, the sky in an outdoor scene) is toned too dark, not only will the retouching be far more noticeable, but the image may suffer from a shift in the logical tonal scale, producing a loss of the natural or desired original impact. A tonal scale is shown in Fig. 9-13.

When toning areas, *always* work from light towards dark. Begin with the lightest acceptable gray tone for the image area and apply it sparingly. After it has dried, check to see if it is dark enough. Remove the acetate shield or mask if necessary

Figure 9-13. A black and white tonal scale. Always work from light towards dark.

and compare the toned area to the rest of the print to see if it fits the image. If the toned area is still too light, a slightly darker gray can be mixed and applied. Another approach to this process is to locate a gray area in the print image that would work well in the area to be toned, and mix the first gray to as close a match as possible to this selected tone. See Fig. 9-14.

Figure 9-14. (a) In this scene, the sky is far too light and must be toned to properly complete the image.

(b) Here the sky has been toned a light grey. In addition, a few other areas have been lightly toned.

Figure 9-14. (c) White clouds have been added to the sky to soften it and add realism.

THE VIGNETTE

Vignetting is the process of soft-fading the background of an image to highlight a desired subject or area. This process is similar to the halo effect discussed above, except instead of separating the subject from the background with a light halo area, vignetting lightens the background gradually as it recedes from the subject. The paint application procedure in both instances is the same but the visual results are quite different as the emphasis is shifted from one area to another. See Fig. 9-15.

Figure 9-15. A vignette of a very light tone has been sprayed around the main subject of this print.

GLOSSARY

BACK LIGHTING A photographic term for a situation where the light source is behind the object that is being photographed. This effect can also be produced by retouching (see *Halo*).

EXTENDED PRINT EDGE An extension of the side, top, or bottom of a photographic image to accommodate an area of superimposed type, or to allow the print to better fit a proposed layout. This procedure is usually accomplished with the air-brush and an acetate overlay.

FLAT TONES FOR PRINT OVERLAYS (OPAQUE OR TRANS-PARENT) An air-brushed, soft-edged tone (either light or dark), designed to obscure a portion of the photographic image so that print or type may be placed over it and be seen clearly. This may be done on either the actual print surface or an acetate overlay (see *Superimposed*).

GHOST This effect occurs when trying to cover an area of the print image with an opaque tone which is too thin. Under a bright light, faint traces of the image show through the overlying tone, making it unacceptable retouching.

TRANSPARENT TONES OR WASHES An air-brushed tone which lightens or darkens an area of the print without obscuring the actual image beneath it. An example of this tone use would be to apply it to a background, making it less noticeable, thus making an object or person in the foreground more visually important.

WIPE OR SWAB METHOD Air-brushing a thin, transparent tone over the entire print image area, and then removing paint from areas to be kept clear with a damp swab, or piece of cotton.

10
Photographic Restoration of Black and White Prints

When properly processed in the darkroom and stored under ideal conditions (with regards to light, humidity, and temperature), a photographic print is considered a permanent image. Unfortunately, these ideal conditions of processing and storage seldom occur, and the problem of image stability is compounded by varying factors such as paper quality, developing chemical contaminants, and mountboard contaminants. These last two factors are particularly fast acting with regards to image damage. The darkroom fixing bath, which hardens the emulsion and stabilizes the photographic image, must be completely washed off the print before drying. Otherwise the image will fade and/or become yellow in a short time. Mounting boards also offer a number of storage problems: cardboard, matboard, and many types of inexpensive wood pulp papers are manufactured with the use of powerful acids and bleaches which are not completely removed or neutralized. Photographic prints which are dry mounted, glued, or are in prolonged contact with these materials will absorb these contaminants and become discolored, brittle, or stained. Very old, or antique prints on paper frequently have cracks, chips, or peeling of the emulsion layer in addition to creases, tears, or other physical damage.

The retoucher's job in this area is usually not to physically restore the damage of aging, but to restore the photographic image to an acceptable level. In addition, it is an accepted practice in antique photograph restoration, not to physically alter or change the original print as this may affect its value. All corrective work should be done on an acetate overlay or on a copy print of the damaged original, and then photographed again.

Very early photographs were not often printed on paper, but on sensitized plates of tin (called tintypes) and also on glass plates which were framed with a black paper backing (known as ambrotypes). Regardless of the material or age of a print, the retoucher should treat it as an irreplaceable original and with the utmost care and respect.

Paper prints which are framed under glass must be removed for retouching. However, the retoucher should not dry mount, or rubber cement mount antique prints. The best way to hold the print to a mounting board is to use corner hinges of the kind used to hold photos in scrap books. These will hold the print in place without any glue coming into contact with the print itself. A second method would be to use glassine hinges of the type used by stamp collectors which (if manufacturer's directions are followed) can be safely and easily removed. These methods will hold the print to mounting board securely, so that it will not shift position when acetate is placed over it and retouching begins. See Fig. 10-1.

Figure 10-1. A paper antique print can be held down on a working surface or support with the use of gummed paper corners without harming the print. After tacking down, an acetate overlay can be taped in place.

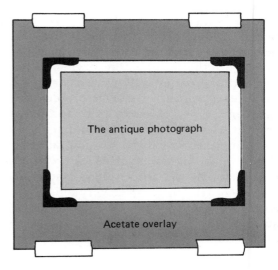

The antique photograph

Acetate overlay

Paint application on the acetate is the same as with all other corrective work. However, the grain structure of the print image may be somewhat different than modern photographs. Many early photographic processes produced an image by a *direct positive* method, meaning that there was no negative. Other processes produced a large format negative which was frequently printed without enlargement (a contact print). In either case, early or antique photographs often have a very fine grain pattern in the image, so extra care must be taken by the retoucher whether using the air-brush or a conventional paint brush.

The area of print color can also add problems in the process of image correction. Antique prints have a tendency (as mentioned earlier) to change color. Usually the original image color was brown–black (as opposed to modern prints which generally have a blue–black image color). Aging tends to alter the brown–black image of these early prints by fading them towards a pale sepia (roughly the color of weak tea). Since a retouched print must be rephotographed to produce the final corrected version, and this is done with modern films and papers, the sepia tones of the original will be translated to a regular black-and-white tone scale. Therefore, the retoucher need not mix a sepia color to match the color of the original, only the proper shades of gray to correct the faded image, or hide surface damage.

When a retoucher is working in conjunction with a photographer on the restoration of antique photographs, certain changes in retouching approaches may be necessary. The photographer may request a certain tone or group of shades for each specific print. Frequently special camera filters must be used when rephotographing an original or corrected print to produce better contrast and clarity. These filters and also some films interpret black and white tones differently than the eye and therefore tones which seem too light or dark may be necessary to achieve a good final print.

suggestions

If the sepia or brown color of an antique print proves troublesome when matching or correcting tones with retouching grays, try testing the tone by looking at it and the original print through a number 25 red camera filter. This will eliminate the brownish tone of the original, and leave just the dark and light

Figure 10–2. (a) In this image, the flaws (cracks or stains) in the forehead must be removed.

(b) Using the air-brush on an acetate overlay, the flaws are concealed and some of the tones in the forehead, cheeks, and nose have been improved.

tones visible. Another practice you may wish to employ when unsure of how a corrected area will appear when the original print is copied is to use a Polaroid camera with black and white film and a close-up attachment to take a quick test print for comparison.

As with many other areas of photographic retouching, antique print restoration has its own special problems. A retoucher who experiments and tries different methods will, over a period of time, develop approaches and techniques which will lead to a better chance of success in each new assignment. See Fig. 10–2.

(c) In this antique print, the corners have faded badly and there is a vertical scratch in the emulsion to conceal.

(d) In the corrected version, a new tone has been applied to the overlay for the sky, dark areas on left and right, and to the figure and the tones along the scratch manually touched up.

GLOSSARY

AMBROTYPE A very early photographic process which produced an image on a glass plate which had to be backed with a sheet of black paper in order to be properly seen. These are quite rare today and are considered to be collectors' items.

CONTACT PRINT A photographic print produced by placing a negative on a piece of photographic paper (holding it flat and in contact with the emulsion surface with a glass plate) and exposing to a light source. This process can be done without an enlarger because no magnification of the image is needed.

DIRECT POSITIVE A photographic process which produces a positive picture image without a negative. Direct positive films, papers, and laboratory processing have many applications in industrial photography. A color slide film is an example of a direct positive film.

FIXING BATH Also known as Hypo. A liquid chemical mixture used in the darkroom to harden the emulsion of a photographic print after it has been in the developing bath. This treatment stabilizes the print image. If a print is left in the hypo bath too long, or is not thoroughly washed afterwards, it will bleach and fade in time, or produce discolored areas.

GLASSINE HINGES Small gummed strips of paper used by stamp collectors to hold stamps in place on album pages.

RED FILTER A transparent red glass disc, in an adaptor which screws onto the front of the camera lens. In black and white photography, this filter produces negatives which render their subject matter with a higher degree of contrast. This filter has many uses in outdoor, studio, copy, and industrial photography.

RESTORATION A term used to describe the process or processes by which a retoucher (in conjunction with a photographer) restores to an acceptable appearance, an old or antique photographic image.

SEPIA A color, roughly yellow-brown, or reddish-yellow-brown which is commonly the color of antique photographic prints. Sometimes modern prints are chemically toned, or stained sepia, to give them a feeling of age which complements their subject matter.

TINTYPE A popular early photographic process which produced an image on a sensitized tin sheet. Some of these prints were hand colored.

148

11
Retouching the Negative

CHAPTER 11

Retouching and other extensive corrective work done on the photographic negative is rapidly falling into disuse in the photographic industry. There are several reasons for this, not the least of which is the vast increase, in the last few years, of the use of cameras which use 35 mm or smaller film formats. Advances in darkroom technology have given the photographic printer a whole new vocabulary of techniques to produce better prints, faster than ever before.

The increasing acceptance by industry of small film format cameras where once only large format cameras were used, coupled with darkroom advances such as stabilization processing and the use of variable contrast printing papers, has led to discarding the once popular technique of negative retouching. However, since there are still some technical and artistic situations which call for negative retouching, a description of this procedure is justified.

The retoucher who is faced with a negative retouching problem will experience many technical limitations. Negatives smaller than 4 X 5 inches are very difficult to work on either with the air-brush or manually. The emulsion image is too small

and intricate. When enlarged to print size, even a microscopic flaw in paint manipulation will be a very blatant mistake.

Another limitation is inherent in the retouching method itself. The process of applying paint to a print surface or acetate overlay is meant to cover-up and disguise flaws, or in some other manner change the tonal structure of areas of the image. For positive retouching, paint is usually opaque or at the very least semitransparent. Positive print retouching is a technique of building up paint over an area, a *cumulative* process. When dealing with the photographic negative, which must be transparent or semitransparent, the cumulative nature of retouching has an effect of limiting the amount of tone manipulation possible for the print.

Figure 11-1. Here is a negative and its' positive print. Note that areas of the negative that are light print as *dark* in the positive image. Areas that are dark in the negative appear light in the positive print.

Retouching areas of a negative can produce *lighter* or *white* areas on the print, but this method cannot make areas *darker* or *black*. The reason for this is quite simple—paint does not transmit light, it blocks it out.

On the negative, the areas which are densest or darkest will produce the lightest areas on the positive print when it is processed. The dark areas of the negative block out or limit the light from the enlarger light source that reaches the print paper during exposure. The transparent or thinner areas of the negative permit more enlarger light to pass through to the paper, thus creating darker areas. See Fig. 11-1.

Figure 11-2. (a) In negative silhouetting, the larger the negative is, the easier the process becomes. In this 2¼-inch square negative, the upper edge of the car is to be silhouetted.

The film opaque paint, ally applied to the glossy of the negative with a brush (such as the type d in print spotting), ex-ds across the entire ative.

Retouching paint, which is generally opaque, when applied to the negative limits even more the light passing through and creates lighter or white areas on the positive print. This is a useful effect if a white silhouette is required. That is, by painting a dense, opaque paint on selected areas of the negative, pure white areas can be introduced automatically to the print when it is processed. See Fig. 11-2.

Instant silhouetting has many applications in technical and product photography, and is accomplished with the use of a

Figure 11-2. (c) The opaque blocked negative can be printed as many times and in as many sizes as is needed.

(d) The opaque paint can cover as little or as much of the negative area as is required.

154

(e) Since the blocked area of the negative does not print, it remains the pure white of the paper. Tones or backgrounds can easily be air-brushed into these areas.

specially prepared paint called a *liquid opaque* or *blocking solution*. This water-based paint is very dense, and is created specifically for use on negatives. It is highly flexible and does not have to be applied very thick as ordinary retouching paints would have to be to achieve the same effect.

Before entering into paint application techniques, an explanation of negative surfaces is in order. The photographic negative has two sides: the *back* and the emulsion side. The back of the negative is smooth and glossy, and when the negative is placed into the enlarger for printing, the back is always placed up, towards the light source to insure that the image is correct and not reversed. A photographic image which has been deliberately printed in reverse is referred to as having been *flopped.* See Fig. 11–3.

The *emulsion side* of the negative is the side which carries the actual image. The emulsion is a coating applied to the film base, and as such is softer and must be treated with great care. The retoucher should always handle negatives by the edges, and not allow fingerprints or any contaminant to come into contact with the image area, *especially* the emulsion side which is very

Figure 11-3. Whether printing the negative in the darkroom or retouching it, the image is correct when the glossy side of the negative is up. However, the negative can be printed either way. Here, the left image is the original scene and the right image has been reversed or flopped.

difficult to clean without damaging the delicate image structure. Keep in mind that the tiniest fragment of hair or particle of dirt which might become part of the emulsion layer will become greatly enlarged when a print is made. Because of the delicate nature of the emulsion layer, the retoucher should try to work on the back or glossy side of the negative whenever possible.

Several different opaque blocking paints are currently being manufactured. These have different mixing and application properties and manufacturers' instructions should be carefully read. Certain universal precautions should also be exercised. Film is considerably more flexible than photographic paper and great care must be taken not to bend or flex the retouched negative too much during handling. Cracks, chips, or pinholes in the opaque blocking paint that can occur from excessive handling of the negative will produce dark streaks or spots in the white areas of the positive print when it is enlarged.

Blocking opaque can be applied manually with a fine brush or a small cotton swab, or even with a pen point (when fine white details are called for) (See Fig. 11-4.) Some types of blocking paint are prepared for use on the emulsion side of the negative, and in this case extra care should be exercised during application because in the event of a mistake, removing paint from the emulsion side is far more difficult than removal from the back of the negative. The emulsion side of film is similar in delicacy to the emulsion surface of print paper;

Figure 11-4. Negative opaque paint can also be applied with a fine pen point. Here, the white lines in the car door, and the other line areas were placed with a pen. The pen is much more difficult to control than a fine pointed brush so experiment with some spare negatives before attempting to use this technique on an actual job.

mistakes in paint application must be washed out and this process increases the risk of water damage, scratches, or blistering of the film emulsion. Negative opaques are usually manufactured in a black, or red color, and come in tubes, small blocks similar to water-color pans, or in liquid form.

Another paint preparation for negative retouching is a *dodging* color. This semitransparent paint acts on the image by holding back but not eliminating image details in the positive print. Like silhouetting, dodging is a selective process, but in dodging the retouched areas can be made to print lighter (because some of the light passing through the negative is held back by producing denser areas). However, it does not totally eliminate details to pure white. The term dodging is also applied to a darkroom practice of holding a cardboard stencil or the hands between the enlarger and print paper during exposure to produce lighter areas on the image by lessening the amount of time the photographic paper is exposed to light. Although the methods between negative retouching and darkroom dodging

may differ, the results produced are very similar. As with the opaque materials, dodging colors are produced in different packages (tubes, pans, and also in liquid form) and manufacturers' instructions with regard to application and mixing different densities should be carefully read before proceeding. Note that here again, care must be taken in handling the retouched negative to prevent cracks and chips occurring in the painted areas. See Fig. 11–5.

In recent years, the increased use of variable contrast photographic papers has caused the process of negative dodging to be used much less than it once was. The variable contrast method utilizes a special photographic paper which can produce different grades or increments of image contrast through the use of colored filters placed in the enlarger and altering the projected negative image. Before this process came into use, photographic paper was manufactured in separate contrast grades. While negative retouching with a· dodging color works with conventional enlarging papers (which are still manufactured and available), the addition of a red dodging color to the complex balance of variable contrast filter colors makes it very difficult for the darkroom technician to produce exact results.

The negative retouching processes discussed thus far have been additive or cumulative methods by which paint is placed over the negative image to achieve an image alteration. This alteration is primarily concerned with removing details and adding the white of the paper in their place, or lightening selected areas and minimizing detail. See Fig. 11–6.

There is also a subtractive process which produces a darkening effect in negative retouching but because of its radical nature (since the negative cannot afterwards be restored to the original state) would only be used under specialized circumstances. This process involves scraping away the negative emulsion with a razor blade or stencil knife, leaving only the film base. The result of this process is the unrestricted flow of enlarger light through the scraped or clear areas of the negative producing corresponding very dark areas on the print. Large areas of the negative cannot be cleared as scratches and gouges in the film base will be apparent in the positive print. However, if black highlights of a limited nature are required as part of the negative this method can be employed. A stencil knife, penknife, or razor blade should be used on the emulsion side of the film to gently scrape the soft image layer away. It should be noted that this is a last resort method of negative alteration and

Figure 11-5. (a) A *dodging* paint can be applied to the negative with a fine brush or (if the negative is large enough) with the airbrush and masks or stencils.

(b) The central area of the original negative was sprayed with a fairly heavy layer of semitransparent dodging color to demonstrate how it holds back the image during the printing.

if black highlights or silhouetting are required all efforts should be made to work on the positive print.

One of the most useful tools of the negative retoucher is the *light-box* or *light-table,* which is a frosted glass or white plastic working surface illuminated from beneath by incandescent bulbs or fluorescent tubes. These are ideal for illuminating the negative while retouching it, and they also provide a clean snag-free working surface that minimizes the chance of damaging the delicate film emulsion. Negatives can be taped down on the light box plate, or can be held in place by the corners during retouching. See Fig. 11-7.

A good quality magnifying glass is a most useful tool for this delicate work; it can be of the hand-held type, or mounted

Figure 11-6. (a) Pin holes are small clear holes or scratches in the emulsion of the negative. If printed with these flaws, black dots or spots will show up on the positive print.

(b) Pin holes can be retouched with a fine (double 0 or triple 0) brush and either opaque or dodging color. When printed, if they show up at all, it will be as light or white spots which can be touched up on the print in the conventional manner with spotting dye.

on a stand or flexible arm to allow the retoucher to keep both hands free. See Fig. 11-8.

Negative retouching, like positive print retouching, is a process that utilizes great skill and patience. If negative retouching is to be part of your regular retouching duties, it is highly recommended that extensive practice on scrap negatives be undertaken to increase your familiarity with the process, and potential problems which might be encountered.

Figure 11-7. A light box, such as this one, or a light table is a great aid in retouching negatives as it supplies a light source from behind.

Figure 11-8. A large good quality magnifying glass, either the hand held or "goose-neck" type (seen here), is most useful in retouching both negatives and positive prints.

GLOSSARY

CUMULATIVE PROCESS A process by which something is added to an original. Both print and negative retouching are cumulative as they add paint or other materials to the original print or negative.

DODGING A darkroom technique by which parts of the projected negative are *held back* by a cardboard stencil or the hands, to shorten the exposure of selected areas of the print, producing a lightening effect. Also a term applied to a negative retouching paint which produces similar results.

FLEXIBLE ARM MAGNIFIER A magnifying glass mounted in a holder on a goose-neck or movable arm and base. Useful in viewing the

negative or positive print, up close, while keeping both hands free to work. Some models have a built in light and are available in different powers of magnification.

FLOPPED PHOTOGRAPH A positive or negative image which has been reversed. A mirror image.

LARGE FORMAT CAMERAS Cameras which use sheet or roll film and produce negatives 2-1/4 in. square or larger.

LIGHT BOX, LIGHT TABLE A white frosted glass or plastic surface illuminated from beneath by bulbs or fluorescent tubes, used for retouching negatives, sorting and viewing slides or film. Also has applications in tracing and mechanical drafting.

LIQUID OPAQUE BLOCKING SOLUTION A specially formulated water-based paint, of a black or red–black color. Used to block out portions of the negative to produce a silhouetting effect in the printed positive. Available in tubes, pans, and liquid form.

NEGATIVE Photographic film which carries a developed reverse tone image which must be exposed on photographic paper to produce a positive image.

NEGATIVE BACK The glossy side of the negative film.

NEGATIVE EMULSION SIDE The side of the film which carries the light sensitive coating and, after development, the negative image.

PIN-HOLES Small *holes* in the emulsion, or retouching paint on the negative that causes dark spots to appear on the positive print.

SMALL FORMAT CAMERAS Cameras which use 35 mm or smaller size film.

STABILIZATION PROCESSING A machine used in the darkroom to rapidly develop and process photographic prints. This system utilizes specially prepared paper, and circumvents the usual tray development of photographic paper.

VARIABLE CONTRAST PHOTOGRAPHIC PAPER A photographic paper capable of producing different contrast shades by being exposed to the photographic negative projected in conjunction with specially colored filters.

12
Servicing the Air-Brush

CHAPTER 12

Mechanically, the air-brush is quite complex and contains many finely machined parts designed to withstand much use over long periods of time. However, like any machine, parts become loose, stuck, worn out or simply break over an extended period. The retoucher, like any technical artist has, as part of his duties, a responsibility to keep tools clean, in good order and operating condition. Major repairs of a broken air-brush, which require replacement of primary parts will probably be beyond the abilities of the retoucher and certainly in this case the brush should be sent to an authorized professional repair source, or to the manufacturer itself. However, internal cleaning, many adjustments, and minor repairs can be performed by the retoucher with a proper knowledge of air-brush mechanical structures.

The mechanical structure of the air-brush can be divided into two parts. The system which carries, directs, and releases the air-flow, and the system which holds, regulates, and transfers the flow of liquid (paint). These systems overlap and are

interconnected in the case of the double-action (retouching) air-brush since the air and paint flow meet and mix in the brush and produce the actual spray.

Cleaning procedures such as flushing the brush during and after the retouching job, cleaning the color cup, and the back-flush cleaning method have already been covered in earlier chapters. While these actions keep the brush clean during use, paint and contaminants do build up and periodic strip-down of the brush for cleaning and adjustment of internal parts is a necessity. How often it is necessary to perform a brush strip-down depends on how heavily the brush is used.

Many air-brush malfunctions can be traced to clogged internal parts, and these usually are indicated by a group of outward symptoms. When the air-brush does not perform properly, strip-down for cleaning should always be done first, before replacing parts is considered.

Retouching paint, because it is meant to be very opaque in thin layers, contains a very high concentration of pigment (finely ground powder which is the color portion of the paint). When the paint is thinned down to a consistency for air-brush spraying, it leaves a thin, chalky residue on the internal color transferring parts of the brush.

The areas where paint residue is most likely to collect or build up are on the forward part of the needle, in the tip assembly, in the exterior spray cone, the color feed tube, and the color cup itself. (Cleaning the color cup has been covered in an earlier chapter.)

Symptoms of paint residue build-up are 1) misdirected spray, 2) no spray, 3) sluggish or jammed pull-back on the spray button and 4) brush color volume does not respond properly to button lever movements.

All of these symptoms can be caused by mechanical defects as well as paint build-up; therefore parts should be inspected as well as cleaned during the strip-down.

The primary part of the air-brush, as far as color transfer is concerned, is the needle. The needle passes through an adjustable chuck or holder which is spring loaded, through to the spray tip assembly. The spring loaded chuck is moved by the spray button-lever so that when it is moved back, the needle retracts a small amount in the spray tip, creating a larger orifice, and therefore an increased spray volume. Obviously, the proper function of this entire assembly is interrelated. Extreme care should always be taken to insure that the needle is not bent,

especially the delicate tip, which is easily damaged if the needle is removed from the assembly too roughly, or if the air-brush is accidentally dropped on the tip. To remove the needle, unscrew the handle, and loosen the *needle locknut,* and then, with the button lever in the forward position, gently slide the needle out. Do not rotate or unscrew the needle, a gentle pull and slight twist should be sufficient. See Fig. 12-1 through Fig. 12-3.

If the needle does not readily withdraw, *do not force it,* it is probably held by hardened paint. Reassemble the brush, and try spraying some warm water through it. After trying a warm water spray, dry the brush and remove the color cup, and try to disassemble it again. If the needle is still stuck fast, try pulling it out with the use of pliers. Make sure the needle locknut is loose, and the spray button lever is in the forward position. Take two pieces of masking or electrical tape and place them over the "jaws" of the pliers to protect the needle shaft from

Figure 12-1. Before taking any portion of the brush apart, it is good procedure to disconnect the air hose. This makes handling the brush much easier. Use the small wrench usually supplied with the air-brush, turning in a clockwise direction.

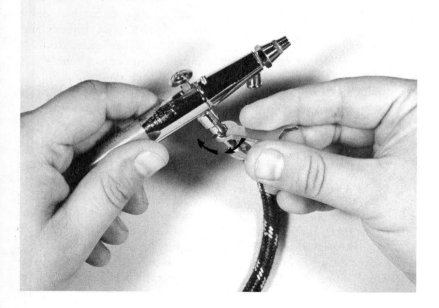

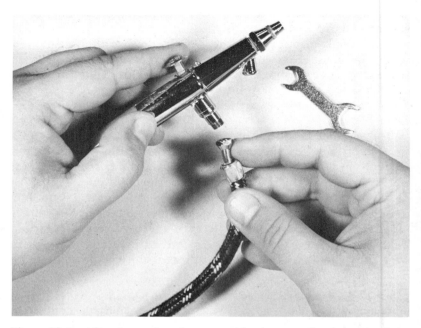

Figure 12-2. After loosening the nut with the wrench, the rest of the unthreading can be done with the fingers.

being scored or chewed by the metal blades. Grip the needle firmly and pull the needle free, with a slight twist if necessary. If the pliers method is used, examine the freed needle carefully, to insure that the shaft and tip are not damaged or bent. (Fig. 12-4.) When cleaning the needle or internal assemblies of the air-brush, always use a cotton swab or tooth-pick swab. *Never* clean any internal mechanism with a metal instrument unless it is specifically designed for the air-brush (as is a *tip-reamer*).

Many brands and types of air-brushes are supplied with extra needles, a reamer, and a spare spray tip assembly as well as a small wrench for connecting the brush to the air hose and for removing the spray tip assembly. The retoucher should make a special effort to study the diagrams of the internal mechanism and (if extra parts are not supplied with the brush) obtain a supply of spare parts.

Another trouble spot, as far as paint build-up is concerned, is the spray tip assembly. If a brush is not carefully and frequently flushed clean (preferably after each use) any paint remaining in the spray tip assembly can harden and jam the

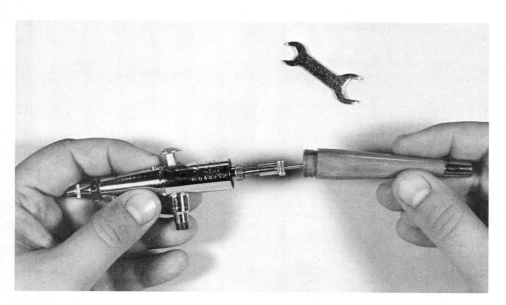

Figure 12-3. (a) To remove the needle first unscrew and remove the air-brush handle, exposing the needle action assembly.

(b) The needle action assembly is the portion of the air-brush that controls the movement of the needle during operation, and therefore, the paint flow. The end of the needle protrudes from a small ribbed wheel that acts as a chuck, holding the needle rigid in the assembly. Loosen this locking wheel before attempting to remove the needle.

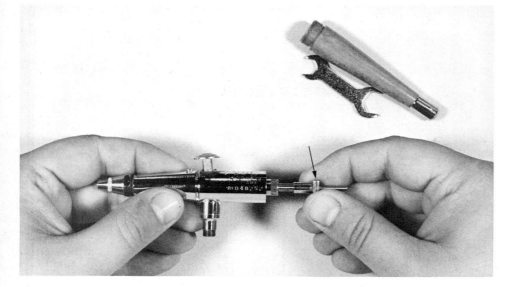

169

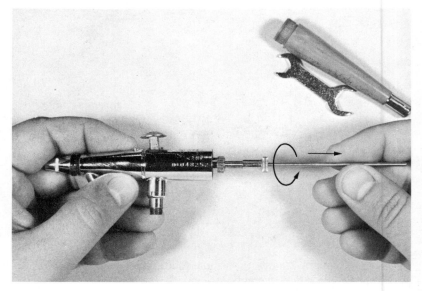

Figure 12-3. (c) After loosening the locking wheel, remove the needle with a slight twist and gentle pulling action.
(d) The needle extends completely through the brush, and because of its relatively fragile nature, should always be removed before a major brush stripdown.

needle, make it retract sluggishly, or misdirect the spray flow, to say nothing of contaminating the next paint color used in the brush.

To remove the spray tip assembly, first remove the needle (as described earlier), then with either the wrench supplied with the brush, or a pair of taped pliers, unscrew the spray head of the brush.

Figure 12-4. (a) If the needle still does not readily withdraw, even after spraying warm water through the brush, a pliers may be used. Put a small piece of electrical or masking tape on the inside of the jaws to protect the needle end from being scored or gouged.

(b) Grasping the needle near the end, *gently* rotate and pull it out of the brush. If the needle or its tip are bent during this process it will have to be replaced.

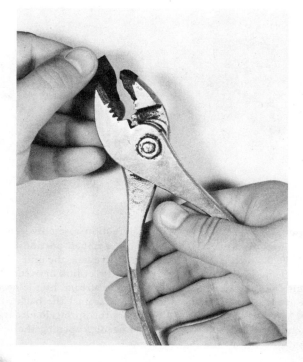

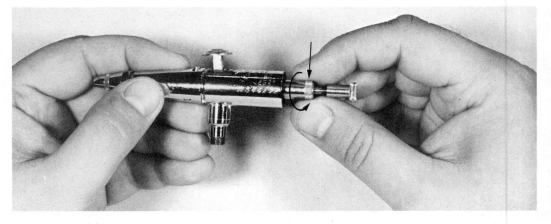

Figure 12-4. (c) The entire needle action assembly can be removed by unscrewing it from the main body housing. There is usually a ribbed portion on the assembly (similar to the ribbing on the needle locking wheel) to aid in unscrewing the unit.
(d) The needle action assembly is the direct link between the spray button lever and the amount of paint color mixed in the tip with the air stream, by the needle itself. The small hinged metal tab on the front of the action assembly rests against the back of the spray lever. When the finger moves the lever back, the tab (#1) pushes the spring loaded needle sheath (inside the needle action assembly) back, and therefore the needle, opening the orifice in the tip wider and allowing more paint into the air-stream.

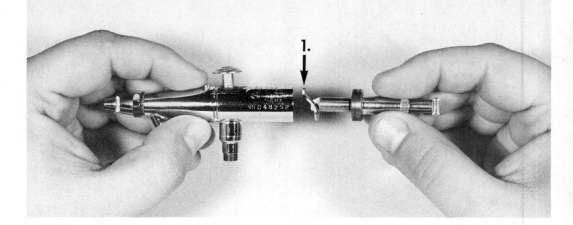

If, when the air-brush is in use, the paint does not spray, but bubbles back into the color cup (as in the back-flush method of cleaning described in Chapter 7), this is an indication of a clogged or damaged spray tip, or bent needle tip.

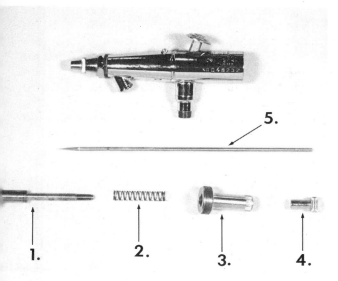

(e) The needle action assembly broken down to its components. 1. the needle sheath with small rocker tab mentioned earlier. 2. a small spring which is placed on the sheath (to allow the needle to spring back to the closed position when the spray button is released.) The sheath with the spring fits through. 3. the needle action housing which itself threads into the main air-brush housing. 4. the needle locking wheel which holds the entire assembly together and also the needle. 5. rigidly in the brush.

(f) The sheath and spring of the needle action assembly should occasionally be lubricated with one or two drops of oil, to keep the needle movement, and the finger lever button movement smooth and snag free. Do not use oil anywhere else in the brush unless indicated. Reinserting the assembly into the air-brush housing, make sure the rocker tab is upright as shown and resting against the back of the finger lever. Note that how far the needle action assembly is screwed into the main air-brush housing determines the resistance of the spray lever button. If more tension is needed, screw the assembly in an additional few turns; if less tension is needed, unscrew the entire assembly a few turns.

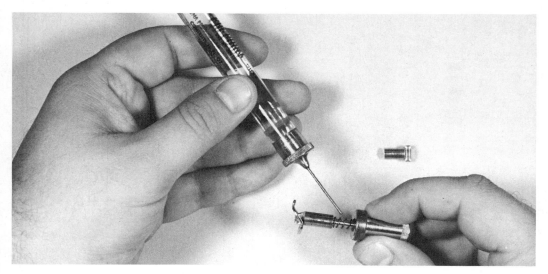

173

Many air-brushes are supplied with a steel *reamer* needle to help clean the spray tip. This device resembles the air-brush needle, except that a portion of the tip has been ground to a sharp blade edge. The reamer is inserted into a clogged or soiled tip, and *gently* rotated to produce a shaving action which removes contaminant paint and particles. The key word for the use of the reamer is *gentle,* excessive pressure of the reamer into the tip, or an excessive number of rotations could shave away some of the metal, causing permanent damage to the tip. See Fig. 12–5.

After cleaning, reaming (if necessary), and reassembly, spray some warm water through the brush to flush out any remaining particles of paint, and check to see if the spray direction from the tip is straight (use a piece of scrap paper to sight the spray on). If the area of coverage is too high, or wet on one side, the brush is not spraying properly due to some clogging or misalignment. This will adversely affect the retouching procedure if allowed to go uncorrected. If the misdirected spray persists after cleaning the brush, replacement of the needle and/or spray tip assembly should be considered. See Fig. 12–6.

Figure 12-5. (a) The air-cap is a small threaded portion of the air-brush tip that serves to protect the finely ground point of the needle, the air-tip, as well as focusing the air/paint stream.

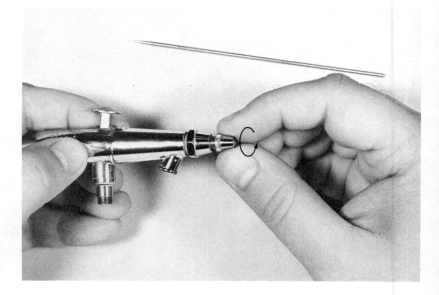

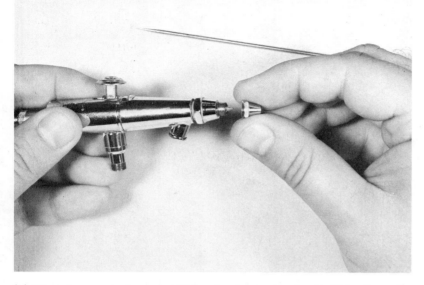

(b) The air-cap can be removed by simply unscrewing it. This allows for cleaning not only the cap itself, but the needle point and the upper portion of the air-tip, as well. If the air-cap becomes dented or otherwise damaged, (such as might happen if the brush were struck against a hard surface) it can adversely affect the spray action. A damaged air-cap should be replaced.

(c) The air-brush head is unscrewed with the aid of the small wrench. Turn it in a counter-clockwise direction to loosen the unit.

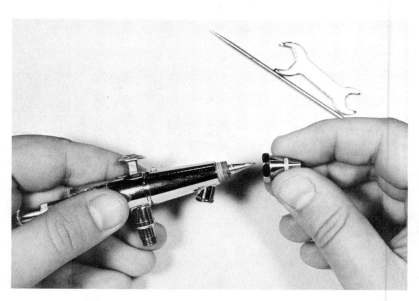

Figure 12-5. (d) When the air-cap is removed, the entire air-brush tip is exposed. The tip is a finely ground and polished metal cone through which the needle passes. In the forward, smallest portion of the tip is a small orifice from which the needle point projects. Because of the back and forth action of the needle, this area is subject to wear as well as paint clogs.

(e) The air-brush tip (2) is seated in a small opening in the main body (1) and can be removed for cleaning or replacement by rocking and wriggling it gently with the fingers. It does not have to be forced back all the way when being replaced. The tightening of the air-head (3) on its threads will properly seat the tip.

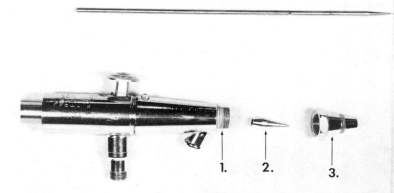

1. 2. 3.

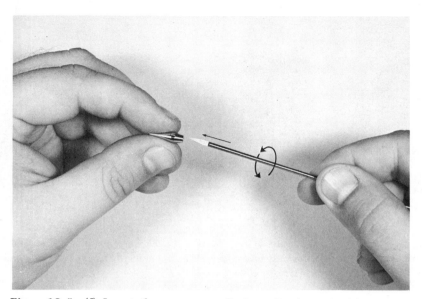

Figure 12–5. (f) Insert the reamer needle into the tip, and with a gentle pressure, rotate it in either direction. Blow air through the tip after reaming, and reinsert into the air-brush. The air-brush shown in this chapter is a Paasche VL–1.

Figure 12–6. (a) Spraying problems related to a malfunction or misalignment of the needle or tip. Air-brush 1 sprays off center. Check for bent needle, improperly seated tip, dents or paint blockage in part of the air cap. Air-brush 2 sprays straight, but spits during spraying. Check air-pressure, paint thickness, blockage in the air-cap, broken needle tip, or cracked tip. Air-brush 3 sprays evenly and well, but the color flow does not shut off when the spray button lever is all the way forward. Check to see if the tip is enlarged or worn, loosen needle locking-wheel and make sure the needle is all the way forward in the brush, then tighten the needle locking wheel securely.

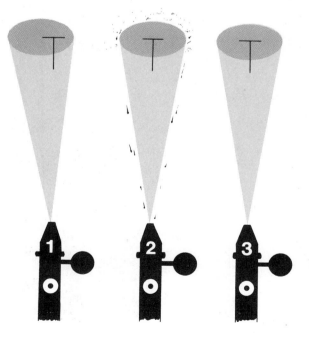

Figure 12-6. (b) Spray area 1 is too heavy and wet on one side. Check for bent needle, tip or blockag[e] air-cap. Spray 2 is more even but has spitting and specks present. Check needle tip wear, enlargement o[f] opening, blockage of air-cap. Spray area 3 is a normal dark tone.

(c) *Needle* 1 shows a badly bent tip, it should be replaced. *Needle* 2 shows a worn tip. The white area should be the true point and shape. *Tip* 3 shows a crack in the opening. This cannot be repaired, the tip must be replaced. *Tip* 4 shows an enlarged opening caused by either allowing the needle to snap back often and too hard or reaming the tip too much.

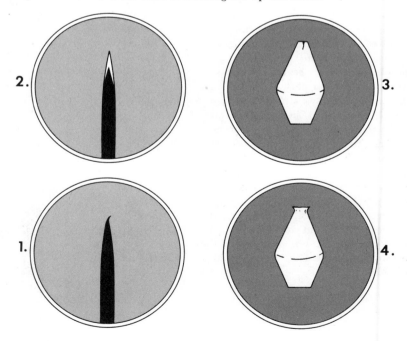

Sometimes, after the tip assembly has been removed and then replaced, water or paint will bubble out of the threaded front portion of the brush between the body and the spray assembly. If this occurs, try tightening the spray tip, or if it is already tightened all the way, unscrew it and check to see if the internal spray tip parts are properly aligned. See Fig. 12-7.

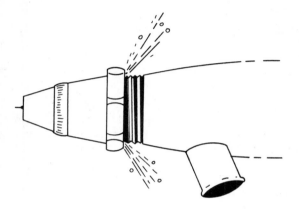

Figure 12-7. If after threading and tightening the air-head back onto the brush body, air and/or paint bubbles out of the threaded area between the body and the head, try tightening it slightly. If this is not effective, remove the head, check for misalignment of the tip due to improper seating or blockages, then replace the head and try again.

BRUSH LUBRICATION

The use of oil is not recommended for the air-brush internal mechanism. Oil, because of its fluid nature, does not stay in one place, and can interfere with proper functioning if it leaks into areas where it shouldn't be. The best lubricant for the air-brush is petroleum jelly (such as Vaseline) or a standard white grease (as used for automobiles). Grease should be applied in very sparing amounts with a toothpick to the back of the finger button lever and/or the needle rocker where it comes into contact with the finger lever. Also, if necessary, lubrication should be applied to the exterior of the needle spring housing. See Fig. 12-8.

Lubrication is important in reducing friction between air-brush parts and reducing premature breakdown. It also ensures that the brush action will be smooth and consistent.

With time and experience, the retoucher will develop a familiarity with the more frequently occuring air-brush problems, and develop unique and personalized methods of dealing

Figure 12-8. (a) The spray button lever can also be removed for cleaning and lubrication. This can be done only if the needle is removed first. The needle passes from the needle action assembly in the back of the brush through a slot in the spray lever button and on to the head assembly. After the needle is removed simply pull the lever up.

(b) A small amount of Vaseline or white grease can be applied with a toothpick to the piston at the bottom of the button lever (1) to lubricate the air valve in the main body housing. In addition, a small drop of oil can be placed on the pivot joint (2), and then wiped away. Do not use oil on piston 1 as it may foul the air valve that it fits into. Reinsert the button lever by aligning it and pushing gently into place. When reinserting the needle into the brush, if resistance is met when it passes through the slot in the button lever body, pull the lever back slightly. If this does not help, withdraw the needle, and then the button lever and try again. *Never* force the needle.

180

with the cleaning and strip-down/lubrication procedures. No one can perform a job properly if your tools fight you or are unreliable or unclean.

GLOSSARY

AIR-BRUSH NEEDLE A steel needle running the length of the internal mechanism which is the connecting, regulating link between the control button lever and the spray volume of the brush.

AIR-BRUSH STRIP-DOWN The process of taking the air-brush apart to clean, adjust, or replace parts.

CONTAMINANTS Paint residue which can build up in the internal mechanism of the air-brush (despite flushing the brush after each use) over an extended period of time (see *pigment*).

MISDIRECTED SPRAY Caused by either a clogged or damaged spray tip or needle, this malfunction is characterized by the air-brush spray going off at an angle from the brush tip rather than in a straight even cone.

PIGMENT The portion of paint which is its color. Usually a finely ground powder.

TIP REAMING NEEDLE A steel needle similar to the regular spraying needle used in the air-brush, but with a sharp cutting edge. This is inserted into the tip of the spray assembly and rotated gently to remove built-up paint and clogs.

13
Retouching Color Prints

CHAPTER 13

In recent years there has been a virtual explosion of printed color material in all areas of publishing, printing, advertising, etc. Full color photographic prints are somewhat easier to produce today than in the past. Scientific advancements in the field have streamlined the darkroom color printing process with better chemistry, faster processing, more accurate color rendering, and a wider latitude of special color effects than ever before.

However, color prints are not inexpensive; in fact, the production of a color print costs considerably more than a black and white print, and is far more demanding technically. Today, a professional retoucher should have experience and familiarity with color retouching in order to offer the widest range of skills as part of his or her professional services.

In the realm of advertising, fashion, product illustration, instructional materials, and other kinds of photography, color retouching offers a very real and valuable service since the cost to restage and rephotograph a product or environment can be prohibitive, or simply impossible.

Color is a process which mimics reality far more so than

black and white photography which translates the colors of the original scene or object to a shade scale running from black to white. Therefore, color has visual impact as well as emotional impact. Colors create moods or emotional states in the viewer and also add realism to the image. A color which predominates over others in an image to create a mood effect is often referred to as *atmospheric* color, a color theme which augments the visual image by adding an emotional context. An example of this process is simple toning. A photograph of people in old fashioned clothing gains a visual softness and sense of age if the print is toned sepia, or brown. A black and white winter scene will look colder and have greater graphic impact if it is toned a shade of blue.

Obviously, atmospheric color is transparent color. It is not meant to hide or disguise parts of the image, but to accent them. The opposite of transparent color is *corrective* color, or opaque color which can both hide or alter areas, as well as offer an opportunity for color correction or change.

THE NATURE OF COLOR IN RETOUCHING

The most difficult areas of color retouching is in learning to mix colors to a desired hue and shade, and in matching colors in paint to print colors. Color mixing is a complex process, but if approached systematically, guesswork can be reduced to a minimum, and a proper approach procedure can be established. All the colors of the spectrum are derived from combinations of *three primary* colors. These primary colors are red, yellow, and blue. All other colors can be broken down to these three. Red, yellow, and blue cannot be broken down to constituents and are therefore referred to as *primary*. Theoretically, it is possible to produce any desired color from a combination of the primaries and white or black. See Fig. 13–1.

The primary colors are arranged on a geometrical figure called a *color wheel*. Mixtures of color which are half each of primary colors are called *secondary* colors. Examples of this would be: 50% primary red added to 50% blue produces violet, a secondary color. Fifty percent primary red added to 50% primary yellow results in orange, another secondary color.

Altogether there are *three* secondary colors: orange, violet, and green. These are placed between their constituent primaries on the color wheel. Still more colors are produced by

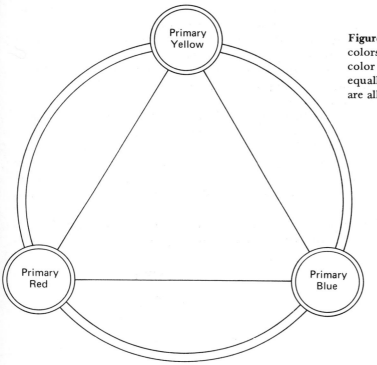

Figure 13-1. The three primary colors are the backbone of the color wheel. They are placed equally distant to show that they are all equally important.

combining the primaries with the secondaries. These are called *tertiary* colors. Examples of these would be: 50% primary blue added to 50% secondary green produces tertiary blue-green. Fifty percent primary red added to 50% secondary violet produces tertiary red-violet. See Fig. 13-2.

Altogether there are *six* tertiary colors. These are: yellow-orange, red-orange, red-violet, blue-violet, blue-green and yellow-green. The color wheel is laid out in such a way as to indicate, at a glance, what the components of a color are. The primaries are placed an equal distance apart on the wheel. Halfway between the primaries are placed the secondaries. Halfway between the primaries and the secondaries are placed the tertiary colors. The color wheel also offers another advantage. If a straight line is drawn from one color through the center of the circle of the color wheel, it will connect to a color on the opposite side. This color is the *spectral* opposite of the first. See Fig. 13-3.

If *opposite* colors are mixed in equal proportion they, in

effect, cancel each other out and produce a dark neutral shade. However, if a small amount of a color is mixed into a larger amount of its opposite, this will darken the color present in the larger amount. For example, to darken green, a small amount of its opposite (primary red) can be added. To darken blue, a small amount of its opposite, orange, can be added etcetera.

In addition to expressing colors, the spectrum is also an expression of individual color intensity. If black paint is gradually mixed with larger and larger proportions of white paint the original pure black will gradually rise or lighten up the scale, through the various grays, until the shade finally becomes pure white. The same process is true of colors. A color starts at *pure* strength, and as white is added, will lighten through various shades up to pure white. These various levels of pure color mixed with white are called *tints*. An example of a tint would be pink (red with white added). The opposite of a tint is a *shade,*

Figure 13-2. The primaries and the three secondary colors. The secondaries are made up of half each of the primary colors on their left and right; therefore, they are placed halfway between the primaries on the wheel. By mixing colors that are *opposite* each other on the wheel in equal amounts, a neutral dark gray results.

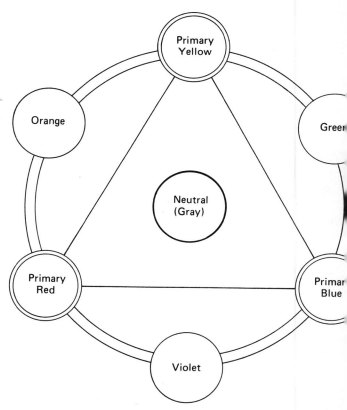

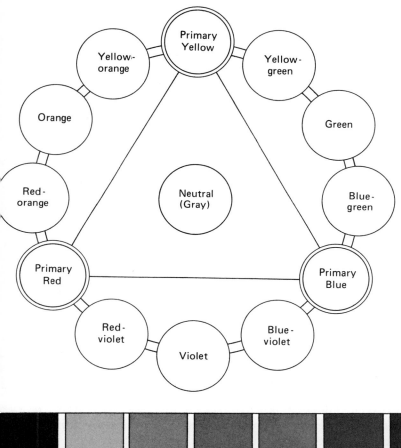

Figure 13–3. The full color wheel containing the three primaries, three secondaries, and six tertiary colors. The tertiary colors are made up of half of a primary and half of a secondary color.

Figure 13–4. A small tint and shade chart. Box 1 can be any color as long as it is pure (full strength.) To the right of (1), small amounts of white are added to create lighter tints in each box. To the left of (1), black is added in increasing amounts to create shades. The number of steps between the true color and white or black can be as many (or few) as it is possible to mix.

where black is added to darken a color. An extensive color-tone chart will have all the colors of the spectrum set in a row with the tints of each color ascending from the pure strength color to white, in various increments. Below each pure strength color, a series of increments will lead to black. Both the color wheel (Fig. 13–3) and the spectrum shade and tint chart are very useful in locating a desired color and determining its components for mixing. See Fig. 13–4.

Remember when trying to mix a color from other component colors on the color wheel that *pigment variance* must be allowed for. There is more than one type of blue, or red, or yellow; different chemicals are used in the production of the coloring element of paints, producing different kinds of the same color. For example, there are several types of blue; there is ultramarine blue, Prussian blue, and Cerulean blue to name but a few. There are many variants of red: cadmium red, crimson, vermillion, naphthol red, etc. All of these variants carry the generic term of their color, but behave quite differently when mixed to produce secondary colors, tertiary colors, tints, and shades. Blue and yellow will always produce green, however the green produced by Prussian blue and cadmium yellow will be a different green than the one produced by combining ultramarine blue and Naples yellow. The same is true of all other color combinations.

There are many kinds of colors manufactured that can be used by the color retoucher. These range from artist's watercolors to special penetrating dyes, and colors produced by photographic processing companies for their own prints. The way these colors are packaged is as varied as the types and number of colors themselves. In order to make a proper choice for individual retouching needs, from a somewhat bewildering range of offerings, certain basic information should be compared to the retouching assignments that will arise.

In most cases, color retouching of the positive print involves changing the color of a selected area or areas to either a new color, or lightening or darkening it. Color retouching, like black and white retouching for industry, implies that the retouched *original* print will be copied or rephotographed for its use. This is especially true of color retouching as almost all retouching procedures of an extensive nature must be done on an acetate overlay. Minor spotting or very small touch-ups can, of course, be done directly on the print surface, but extended areas which, in black and white retouching would require preparation or dry-scrub of the actual print surface, cannot be performed on a color print because of the nature of the color print emulsion. The color print emulsion when dry-scrubbed or scratched will show flaws as colored streaks which only compound the problems of retouching. Color retouching paints are usually water soluble, transparent, water-color type pigments. An opaque color is produced by mixing the color with white

or other colors. It is not advisable to mix colors with retouching grays, as this produces rather muddy colors. Transparent colors have the advantage of being more adaptable to a wide variety of retouching needs. Transparent colors have a greater tinting strength than premixed opaque colors, as well as having many uses as transparent washes.

Watercolors are manufactured in three basic forms: liquid (in bottles), paste (in tubes), and in pans (dried small blocks). There are variations of these basic formats but the widest range of colors will be of these types.

Virtually all high quality artists' watercolors are adaptable for color retouching. The differences between the various formats in which these colors are available is mostly in the area of mixing ease, and the amount and type of color needed for retouching. Liquid colors packaged in bottles are usually dyes; very strong, transparent colors with great tinting strength. Watercolors in tube form or in dry pans are sometimes slightly more opaque in the pure state, but are also very strong color, and can be easily mixed to shades and tints. Watercolors in tubes can be applied to a dish or some receptacle with small indented areas (such as a watercolor palette or even a small plastic ice-cube tray), allowed to dry, and then color can be mixed and prepared by the brushful, by bringing a small amount of water to the dried color.

Whatever type of color is eventually selected, some useful tools to have are: several watercolor brushes of the *round* type (red sable or similar) in different sizes for both mixing and carrying color, as well as manual retouching. (A good selection of sizes would be 0, 1, 4, 6, and an 8 or 10.) In addition, a mixing tray, or palette (which can be a plate, plastic tray, or any easily cleaned surface) is required. A white surface for mixing is recommended as a colored surface makes accurate color mixing difficult.

In addition, small bottles or containers for storing mixed colors, water, white and black paint, etc., are necessary. The plastic snap-cap containers that 35 mm film cassettes are packed in are ideal for this purpose. Small, stick-on labels can be applied to the outside for identification.

As with black and white retouching, keeping the tools, palette, mixing pans, and air-brush clean at all times is a necessity, and the cleaning procedures outlined in other chapters should be frequently used. See Fig. 13-5.

Figure 13–5. Brush number 1 is a fine pointed watercolor brush called a round. It has very soft bristles and is frequently made of sable fur. In the large sizes it is excellent for paint mixture and silhouetting, in the small sizes it is excellent for spotting and other manual retouching procedures. Brush number 2 is a soft wash brush sometimes called a bright. It is useful for mixing paints and a large clean brush can be used to dust off particles of lint and matter from the print surface. Below: an aluminum or plastic circular palette, with nine or more indentations to store and mix color in.

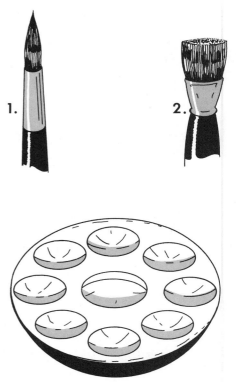

MIXING COLORS

Learning to mix colors accurately, to match a mixed color in paint to an existing color on the print, is a process that takes time and experience to perfect. There are, however, some basic guidelines to use as reference when entering this area.

When mixing a color for a specific purpose, or trying to match an existing color, the most direct route is best. First determine the predominant color in the desired color. This can be done by an eye judgement, but will be more accurate if a color chart and color wheel are used. Many color manufacturers produce color charts of their products and these can be used to tailor-make color combinations to a desired hue by simple comparison. By getting as close as possible on a color chart to the actual desired color, a great deal of experimenting and trial and error is eliminated. Having found the closest color,

other colors can be added, or the color can be lightened/darkened to reach the final color goal. Many color charts, in addition to presenting a small swatch of color for comparisons, will frequently have both the name of the color, and the constituent colors that make it up. Therefore, if the retoucher feels a little more red is needed in the color being mixed, or a little more green, the color chart can be used to determine exactly what colors need be added to achieve the desired effect.

The same direct process used to determine the desired color can be used in the actual paint mixing. If, for example, a greenish-brown is required, it is inadvisable to try to mix first green, with a blue and yellow, the brown, with possibly red, yellow, and green, and then try to produce the desired color by mixing all of these together, as the result will more than likely be a muddy, neutral gray-brown. This is partly the result of pigment variance and partly caused by the simple result of mixing too many colors together, which has the effect of canceling them out. The simplest color mixing is always best. The fewer number of colors mixed to produce a desired hue, the cleaner, brighter, more easily handled retouched area. In the example of greenish-brown, determine which is the predominant color. In this case, it is brown. The next step is to find a brown on the color chart that is closest to the base brown in the color to be mixed or matched. It could be burnt umber, raw sienna, or even yellow ochre (pronounced oakar). Having found the base brown, the next step is to determine which green is to be added, and to what percentage. In some cases, the color is clear enough to use the color chart, but most often a few trial mixings are required at this point, to determine if a yellow-green, or blue-green, etc., is best for the desired hue.

To test mix colors, use a medium size watercolor brush. Dip the brush in clean water and work it gently over the surface of the dried watercolor in its pan or palette compartment to produce a color solution. This can then be transferred to a mixing surface, a full brush at a time. *Never* attempt to mix colors in the compartments or pans where the dried color is kept, as this will only contaminate the pure colors. *Always* transfer color from the pans to a mixing surface, and wash the brush in clean water before taking some of the next color and transferring it to the mixing surface as small droplets or puddles. The colors can then be mixed together a little at a time with a clean brush to the final desired hue, or specific color. See Fig. 13-6. In the case of liquid colors in bottles, small amounts

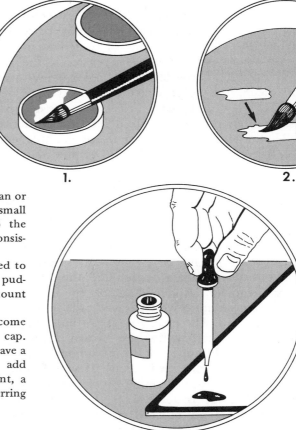

Figure 13–6. (a) When using pan or tablet type watercolors, add a small amount of water directly to the color and work up a paint consistency there.
(b) Transfer colors to be mixed to the palette surface as separate puddles, then draw off a small amount of each color and mix.
(c) Many color dyes in bottles come with an eyedropper in the cap. However, it is a good idea to have a medical type eyedropper to add water and white or black paint, a drop at a time, or for transferring mixed colors to a container.

can be transferred to the mixing surface with a medical-type eye dropper.

OPAQUE COLORS

So far, in this description, the mixing has been of transparent colors. The primary purpose of opaque paints is to cover or mask areas of the original image. In color retouching, this covering action is also linked to actual color change. Since watercolors or dyes are very transparent, a paint element must be added to them to act as an opaque base. White opaque

retouching paint (the same white as used in black and white re-touching) is suitable for this purpose. The prepared liquid type is best as it blends smoothly with watercolors. Tempera or so-called poster color whites are *not* recommended because they flake and crack when dry. *Acrylic* paints, while water soluble when in a liquid form are *not* recommended for retouching use because they dry waterproof, and can clog the air-brush while in use. When mixing an opaque color, the inclusion of the opaque white paint will automatically lighten the mixed watercolor added to it. Therefore, the color mix has to be stronger and darker to produce the desired opaque color when mixed with white. Depending on the combination of colors added to opaque white, the resultant blend may dry either slightly lighter or darker in color than when the paint was in a liquid state. Therefore, when a very accurate color match is required in the retouching, a small color swatch should be sprayed on a piece of scrap acetate, allowed to dry, and then placed over the print image area to be altered, in order to compare the dried paint color to the corrective color that is desired.

When mixing opaque colors, the same procedures as are used in black and white retouching can be employed, with re-gards to the thickness of the fluid, and the amount to be ap-plied to the acetate. Needless to say, if a very heavy layer of paint is to be applied to the acetate, a flexible paint medium (described in Chapter 3) should be added to the paint, just as it is in black and white retouching, to retard shrinking and cracking during drying.

Many manufacturers of tube, pan, and liquid watercolors and dyes, produce their products in sets. These sets contain a selection of colors ranging from as few as 6 to as many as the full product line of the manufacturer. Sets are very convenient, and offer the practical advantage of allowing for a selection of colors to reflect the amount of involvement in color retouching at a particular time. Without obtaining more materials than are necessary, sets also offer the possibility of the purchase of future, more extensive groups of colors to be added, if the in-volvement in corrective color work should increase.

COLOR WASHES

As mentioned earlier, a thin, transparent film of color can be applied to the color (as well as black and white) print image.

This *wash* is not meant to disguise or cover up, but to enhance or heighten the mood or impact on the total image. Color washes can be applied by air-brush directly to the emulsion surface if desired, but like all emulsion surface retouching of an extensive nature, washes are very hard or impossible to clean or remove without damaging the emulsion layer. In addition, washes are, by their nature, delicate rather than heavy or saturated color. It is much easier to control the level of color saturation when working on an acetate sheet, since it removes the risk of having to clean the actual print surface if too much color is applied. Heavy or saturated color can, of course, be applied as a wash also. However, when the wash color is very intense it acts as a *screening filter* and alters the colors of the image showing through from beneath. This heavy type of color wash has value in some types of graphic applications.

In the air-brush application of transparent or opaque color washes, an evenness of overall tone is generally desired. The spraying procedure to produce a flat tone or wash is described in Chapter 8. Transparent washes can also be *selectively* applied; that is, producing areas where the wash color is more intense than others. This selective application is accomplished by simply spraying the areas to be darker, or more color-saturated, for a longer period of time. Since the air-brush is held at a greater distance for washes than for more detailed work, the selective spraying process will produce soft-edged areas of greater saturation, and increases the number of special color effects that can be achieved.

INTRODUCING COLOR TO BLACK AND WHITE PRINTS

A black and white print cannot be truly converted to a regular color image through retouching. This is because the tonal scale and conversion of an original color scene, when photographed on black and white film and printed, has a different interpretation of the colors and intensities than would be produced with color films and printing materials. However, color can be introduced to the black and white image with some interesting and striking results. Color dyes, such as the bottled, liquid kind described earlier can be mixed to any desired combination and applied either manually or by air-brush directly to the emulsion surface of a black and white print or to an acetate overlay. This process quite effectively colors the black and white image,

and although it can be differentiated from a color print image, is both colorful and offers a variety of interesting graphic possibilities. The process is, quite simply, filling the normally gray tonal scale of the print with transparent colors that allow the original image to show through. This is best accomplished directly on the emulsion surface by hand with a small brush. The dotting retouching technique described in Chapter 4 can be employed here, or the air-brush can be used for larger areas. An additional possibility for innovative images with this technique is that naturalistic colors need not be used in the tinting of the image, offering numerous opportunities for graphic experimentation.

ALTERATION AND CORRECTION OF COLOR TRANSPARENCIES

The process of altering or correcting the color emulsion image of transparencies (sometimes called *slide retouching*) by the use of chemical bleaches, and other substances, is a subject area that falls outside the province of this book. Transparency retouching is concerned with darkroom technology, rephotography, and color correction. Although outside of the sphere of the print retoucher I will outline part of the process and some related technical terms.

Color transparencies are positive color images on a clear film base, rather than on print paper. The most immediately recognizable transparency is the cardboard mounted 35 mm color slide. Both 35 mm slides and larger transparencies are extensively used in the publishing, printing, and advertising industries for the selection and composition of printed and illustrative matter. As already described, color photography shares many technical problems with black and white photography, with regards to the composition of the image, and this is where the skills of the print retoucher are called for. However, unlike black and white photography, color materials must convey an image and its color as well. Color films, therefore, are subject not only to light, but to the color of light.

The chemical processing and development of color films, whether negatives for prints, or direct positives, such as slides, is more complex and technically demanding. The color image is influenced by many factors, each of which has the potential to adversely affect the desired image. Not only does the actual

photographing present problems (such as color temperature, unwanted reflections, camera mechanical problems, etc.), but the processing of the exposed film as well (i.e., weak chemicals, processing chemical temperature variations, contaminants, over-developing or underdeveloping, etc.). Obviously, there are a number of factors involved in the production of acceptable color images. Slides or larger transparencies are prone to color saturation problems (either too dark, or too light) or color temperature problems (an overall greenish, blueish, or yellow cast) which spoils the desired image. In some instances, for technical reasons, these image problems must be corrected in the transparency itself, rather than possibly producing a print of the slide, retouching it, and rephotographing the corrected print back into a transparency. In addition, transparencies of good exposure and color saturation can have their images combined to form montages of superimposed subject matter. In both the cases of color correction and preparing transparencies for combination in montages, chemical bleaches are employed.

In color correcting transparencies that are oversaturated in color, or underexposed (generally too dark), a bleaching solution can, in some instances, be applied. This chemical acts on the dyes that make up the color image, lightening and making them less dense and more transparent. This bleach solution is commercially manufactured, and usually applied to the transparency emulsion with a cotton swab or soft brush. After application, the bleaching action is observed, and stopped when the image has lightened to the desired level. If maximum bleaching is permitted, it is possible to virtually erase the transparency image. The bleaching action is quite controllable, and selected areas as well as the entire image, can be treated. After the bleach treatment, the transparency is usually rephotographed.

Because selected areas of the transparency image can be bleached, this process has value in the preparation of montages. Montages are often referred to as *sandwich* transparencies. By bleaching selected areas of one slide, the underlying image elements can be made clearer and less dark. In addition, sandwich transparencies combine their colors, as well as their images, and greater control can be exercised with regards to color saturation. Colored dyes can also be introduced to selectively bleached image areas of the emulsion, thus superimposing new colors on the already existing image.

Color correction of transparencies can also be achieved

through the process of rephotography. This is of great value in the correction of overall color tones that are the result of using the wrong film for the original photography, or improper processing of the exposed film.

Rephotography is more than simply making a photographic copy. It offers the opportunity to adjust the overall color in the duplicate, to reduce or eliminate unwanted or damaging color tones, as well as the possibility of adding new colors that were not in the original. Rephotography is a complex, technical process which requires an extensive knowledge of photographic equipment, lighting, color filtration, films, and darkroom processing.

Additional information on the areas of transparency bleaching and rephotography is available from the manufacturers of bleaching and color processing chemicals, film manufacturers, and camera and darkroom supply sources.

GLOSSARY

ACRYLIC PAINTS Water soluble when in the liquid state, these artists' colors dry waterproof due to chemical changes in the paint. They are excellent for other purposes but are not recommended for retouching.

ATMOSPHERIC COLOR A color which predominates in an image or scene and establishes by its presence an emotional mood or theme.

BASE COLOR The predominant color in a mixed hue. In greenish-brown, the base color would be brown. In grayish-blue, the base color would be blue. Secondary colors do not have base colors as they are composed of equal amounts of the primaries.

COLOR CHART A systematic presentation of colors and/or mixtures of colors obtainable with various types of paint. Many manufacturers produce such charts of their paint products for use by artists and in industry.

COLOR FILTRATION The use of colored, transparent glass or plastic appliances to correct or alter the color content of an original image during

the rephotography process. Filters are also extensively used in photographing the original image, as well as having extensive uses in the darkroom. There are many types of filters for both black and white and color photography and printing.

COLOR PROCESSING Chemical developing of color films or print materials.

COLOR SATURATION The level of intensity of a color. In retouching, the intensity of color of a given area on the photographic image (either of the original processed print or added by corrective procedure).

COLOR SWATCH A small sample of color usually accompanied by its technical name and sometimes with the constituant colors that are mixed to produce it. These small color samples are part of a color chart or can be separate sheets in a booklet form.

COLOR TEMPERATURE In retouching, the overall character of the colors in a color image with regards to warmness (generally pink to yellow) or coolness (blue to green). Different types of color film, processing, and some printing materials will have a tendency towards image characters of one or the other type.

COLOR TONING A transparent layer or wash of color applied over a black and white or color image.

COLOR TRANSPARENCY A positive color image on a clear film base, usually called slides.

COLOR WASH A thin, transparent, uniform color tone, usually applied over the photographic image with the air-brush (see *atmospheric color*).

COLOR WHEEL A geometric figure in the form of a circle, on whose outer edge are placed at equal distances, the primary, secondary, and tertiary colors. The value of the color wheel lies in its use to determine the constituant colors that make up a given hue. A line drawn from one color through the center of the wheel will connect, on the other side with the opposite of the first color, which can be used to darken it, and also produce a neutral color.

CORRECTIVE COLOR A term generally applied to nontransparent paints used in color retouching to mask or cover areas of the print image (see *opaque*).

DIRECT POSITIVE A photographic process which produces a color or black and white image without a negative. Slide films usually employ this process.

FLAT COLOR WASH A uniform, opaque color tone applied to the color photographic image (usually on an acetate overlay) with the air-brush.

HUE A specific color.

MONTAGE An image composed of two or more separate visual elements superimposed on each other.

NEUTRAL COLOR A gray tone produced by mixing colors which cancel each other. A neutral color can be produced by mixing equal parts of any color on the color wheel and its opposite.

OPAQUE COLORS Colors which cannot be seen through. In retouching, opaque colors are used to mask or cover up areas of a print image for corrective purposes. Opaque colors can be produced by adding transparent colors to white or black paint.

PIGMENT The portion of paint which gives it a particular color. Pigments are usually chemical powders or solutions, and vary in make-up and structure in the various colors.

PIGMENT VARIANCE The difference in visual value in hues of the same basic color. Examples of this would be the difference between Prussian blue, ultramarine blue, and others which, while still being basically blue, are variations of that color. Pigment variance is deliberate, and stems from the use of different chemical elements in the paint coloring agent.

PRIMARY COLORS The three colors of the spectrum which cannot be broken down to any constituent colors. In paint, these are red, yellow, and blue.

PURE-STRENGTH COLOR The maximum intensity of a given color that can be produced. (With paint, it is pure color with no white or black added.)

REPHOTOGRAPHY The process of photographing a photograph to incorporate certain changes (such as retouching, color correction, etc.) in the second generation image.

SANDWICH TRANSPARENCY Combining two or more transparencies to create a superimposed composite or *montage* image.

SECONDARY COLORS Colors produced by mixing equal amounts of any two primary colors. There are three: orange, violet, and green.

SELECTIVE BLEACHING The application of a bleach solution to selected areas of the transparency image, rather than to the entire slide.

SELECTIVE TRANSPARENT WASH A thin, transparent color tone of varying density, applied by air-brush over the photographic image, but having some areas of greater color density or saturation, as visual accents.

SHADE The level of intensity of a color which has been darkened either by mixing it with a spectral opposite, a neutral gray, or black.

SPECTRUM A spectrum is the series of colors that are visible to the human eye. A spectrum can be produced by passing a beam of white light through a prism, which will separate it into its constituent colors.

SUPERIMPOSED A process of projecting one image on top of another to create a third. For example, when two or more transparencies are *sandwiched,* and then projected or printed, they will produce a new composite visual effect.

TERTIARY COLORS A third series of colors produced by mixing equal amounts of a primary color and a secondary color. There are six: yellow-orange, red-orange, red-violet, blue-violet, blue-green, and yellow-green.

TINT The level of intensity of a color which has been mixed with white.

TINTING BLACK AND WHITE PHOTOGRAPHS The process of coloring black and white photographic images with colored dyes, either manually or with the air-brush.

TRANSPARENCY BLEACHING Sometimes called slide retouching, this is a process of altering the color emulsion of a transparency with chemical bleaches.

WATERCOLOR PANS Small flat metal, or plastic containers which hold an amount of dried watercolor in a tablet form.

WATERCOLOR SETS Prepared and preselected sets of either pans, tubes, or bottles of color, offering from as few as six to as many as the manufacturers full product line.

WATER-SOLUBLE COLORS Colors which are mixed with water.

Index

A

Acetate:
 extension of print edge,
 130–133
 mask-for halo effect, 114–
 117, 133–136
 masks and shields, 113–117
 overlay for retouching, 12
 overlays for flat tones,
 125–129
 overlays-removing paint from,
 38
 practice stencils, 107
Air-brush:
 activating the air-brush, 85–88
 air-cap assembly, removal,
 174–179
 air source, 82
 background tones, 113
 basic practice exercises, 91–93

Air-brush (*continued*)
 basic spray methods, 91
 brand names, (*see* individual
 company names)
 brands with color cup built
 into head, 81
 button-lever, lubrication of,
 179–180
 removal of, 180
 carbon dioxide tank, 82–85
 carbon dioxide tank supply
 companies, 82
 cleaning the color cup, 89, 99
 cleaning the air-brush, 99–101
 cleaning by the back-flush
 method, 99–100
 cleaning with a cotton swab,
 168
 color cup, 80
 color cup, transfer method,
 88–89